IMAGES
of America

BENBROOK

IMAGES
of America

BENBROOK

City of Benbrook

ARCADIA
PUBLISHING

Published by Arcadia Publishing
Charleston, South Carolina

Printed in the United States of America

Library of Congress Control Number: 2011932251

For all general information, please contact Arcadia Publishing:
Telephone 843-853-2070
Fax 843-853-0044
E-mail sales@arcadiapublishing.com
For customer service and orders:
Toll-Free 1-888-313-2665

Visit us on the Internet at www.arcadiapublishing.com

*This book is dedicated to the citizens of Benbrook, past and
present, for their contributions and commitment to making
Benbrook a friendly and welcoming community.*

CONTENTS

ACKNOWLEDGMENTS

This book represents the collective efforts of the City of Benbrook to document the unique history of the community we serve.

Benbrook residents were invited to donate photographs, documents, and memorabilia for this book. The response was immediate and encouraging. Numerous individuals, some descendants of early pioneer families, generously shared their time and memories. Pouring through photographs, documents, handwritten historical accounts, and old newspaper clippings, the call to share was graciously answered.

It is impossible to individually thank all the Benbrook residents, past and present, who contributed the memories that make up this book. City staff members Cathy Morris, Sarah Stubblefield, and Chris Bobbitt oversaw the project, relying on the participation of Benbrook residents, organizations, and business owners to fill the pages.

We also owe a special debt of gratitude to Benbrook's current and former elected and appointed officials, and city staff members, for not only supporting and encouraging this project but for helping make Benbrook a great place to call home.

Any historical account of a community is bound together by generous people willing to share the personal and collective stories of their lives. Individuals and organizations that made particularly significant contributions to the book include the US Army Corps of Engineers, the Benbrook Public Library, First Baptist Church of Benbrook, R.E. "Bob" Clark, Dr. and Mrs. Jerry B. Dittrich, Chuck Atkinson, Linda Carmichael, Joanne Bowles Eason, Carol Pearcy Shour, Cindy Childers Hughes, Jack Johnson, Jess Jordan, Mary Wallace Layne, Robert Cook, Robert Judson, Carolyn Cartwright, and Alan Cartwright. Photographs that were provided courtesy of "Eugene" were obtained through a photo-sharing website. While permission was granted to use the photographs, staff was unable to obtain the photographer's last name.

We recognize that the story of our city is never fully told and constantly evolving. With a history rich in farm and ranch life, simple living, and reliance on the strength of family and faith, the completion of this book does not mark the end of our search to tell that story. We invite readers to consider contributing additional material for future history projects and archival purposes.

Thank you to everyone who took part in this important work.

—Andy Wayman
Benbrook City Manager

INTRODUCTION

As pioneering families traveled westward across the North American continent, generations left their homes in search of adventure and the promise of a new life. Such was the case for the Willburn family, who traveled from Missouri and settled in the Benbrook area in 1854. Edward and Nancy Willburn arrived as "Family 107" of the Peters Colony. The colony was a project designed to entice settlers, funded by a contract between W.S. Peters of Kentucky and the Republic of Texas. The Willburns were issued 320 acres of land, a log cabin, seed, and musket balls.

Other families soon settled in the area as well. Among the first buildings, outside of homes, were the Mary's Creek Post Office, named after the small tributary of the Trinity River, and a small single-room structure that served as both schoolhouse and Methodist church, built by Edward Willburn.

The schoolhouse that Willburn built collapsed in 1865 and was not rebuilt, because of the Civil War and Reconstruction, until 1872. This new building, called "Old Rawhide," burned down in 1879. By that time, Ed Willburn had passed away, leaving most of his wealth to his daughter, Marinda Willburn Snyder. Marinda donated five acres of land on which the community was to build a new school. The school continued to function as the Methodist church, and a cemetery was later built on the land in 1885. Because of Marinda's contribution of both land and resources to the community along Mary's Creek, the area was known as "Marinda" until 1885, when the school was renamed Benbrook School.

The Benbrook family arrived in the Mary's Creek area in 1876 from Illinois, and James M. Benbrook served as justice of the peace. Benbrook was a prominent leader in the area, and the schoolhouse was renamed in his honor. The area permanently became known as Benbrook after James Benbrook petitioned the Texas and Pacific Railroad Company to build a train station in the area. The railroad agreed and built a station on land donated by James Benbrook, naming it Benbrook Station. Benbrook continued to be a visible figure until his death in 1907. His gravesite is in the Benbrook Cemetery, located on the corner of Mercedes Street and Winscott Road, and is designated with an official Texas Historical Marker.

The Benbrook community attracted ranching families, and several notable homesteads dotted the landscape, as depicted in the following pages. Many of these homes were lost to the inundation of Benbrook Lake in 1947, but the photographs featured in this book provide good insight into what life was like in the earliest days of Benbrook. Ranch owners were not the only people settling in Benbrook in the early days. Many of Tarrant County's most prominent businessmen chose Benbrook as their home, including hotelier Winfield Scott and radio station owner (and US president Franklin Delano Roosevelt's son) Elliott Roosevelt.

With the advent of World War I, English forces needed a place to train pilots of the Royal Canadian Flying Corps. Texas was an obvious choice because of its mild climate, and Benbrook was chosen as the location of one of three airfields in the Fort Worth area. Originally Taliaferro Field, the name of the field changed to Carruthers Field in honor of Cadet W.K. Carruthers, who was killed in a plane crash at the training field in 1917. Carruthers was not the only casualty

at the Benbrook airfield; in fact, the airfield was the site of the most plane crashes of all of the training zones during World War I.

The most notable casualty at Carruthers Field was that of Vernon W. Blyth Castle, a world-famous dancer and performer who joined the Flying Corps. As a decorated pilot, he was assigned as a trainer at Carruthers Field in 1917, along with his beloved pet monkey, Jeffrey, who always flew with him. In the 1917 crash that took his life, Castle managed to maneuver the plane, saving the lives of both his trainee and Jeffrey. The only monument in Benbrook today is dedicated to Castle. Thanks to many contributions, photographs of Castle as performer, pilot, and beloved figure have become a part of this book.

While Benbrook did not grow substantially between 1920 and 1940, the small town adapted well to modern changes, including the proliferation of the motor vehicle and the national highway system. Benbrook also became a part of the growing suburban frenzy, with construction of the community's first housing development, Benbrook Estates. Benbrook Lakeside Addition, begun in 1950, was built on the site of Carruthers Field. At risk of being consumed by neighboring Fort Worth, Benbrook recognized it was time to become a real city. In November 1947, the city of Benbrook was incorporated. Ed Sproles, head of the Texas Motor Truck Transport Company and owner of a sprawling ranch located near present-day Benbrook Boulevard/US 377, was elected Benbrook's first mayor.

Also in 1947, the US Army Corps of Engineers began construction of Benbrook Lake and Dam. This project was intended to reduce flood risk and provide water to surrounding areas. In 1949, the city addressed the need for a water supply and, thanks to the lake, instituted the Worth Water Company. Benbrook Dam was completed in 1950 and began impounding water in 1952. In 1955, the Benbrook Water and Sewer Authority was created by the Texas Legislature and assumed the assets of Worth Water Company. Photographs of these major events in the growth of Benbrook are highlighted in this book, chronicling the efforts of a small city to keep up with growing demands. Today, Benbrook Lake is not only a source of water for the city but also provides many recreational opportunities.

As the government of Benbrook was established, businesses began to flourish as well. Local business owners provided amenities to the community such as grocery stores, restaurants, beauty salons, florists, and skating rinks. This growth increased the appeal of the little town on the edge of Fort Worth.

In 1950, city census records revealed that Benbrook had 617 residents. By 1960, that number had grown to 3,254; in 1980, 13,759; and in 1990, 19,654. Despite this growth (in 2010, the population was 21,234), Benbrook continues to maintain its small-town charm and family-friendly atmosphere.

Many of the photographs in this book depict the people, neighborhoods, businesses, institutions, and recreational amenities that make up the story of Benbrook. As the city continues to meet the unique challenges of growth, the commitment to maintain a welcoming, family-focused, business-friendly environment does not waiver.

One

MARINDA AND BENBROOK STATION

In 1842, the Republic of Texas sought to attract people to the North Texas area by offering free land, a log cabin, seed, and musket balls. In 1843, Edward and Nancy Willburn of Missouri came to the area as "Family 107" of the Peters Colony, later settling, along with several other families, along Mary's Creek, near modern-day Benbrook, in 1854.

Early homesteads were sparse, but residents desired education and worship opportunities. A 20-foot-by-20-foot single-room school building, which combined with the Methodist church, was built in 1857 near the Clear Fork of the Trinity River by Edward Willburn. Classes were held during the winter months but apparently ceased during the Civil War. The school building collapsed in 1865, and in 1872, a new school and church known as "Old Rawhide" was built by the Chapman, Edwards, Ward, Majors, and Willburn families.

"Old Rawhide" was reestablished in 1880 near the intersection of Mercedes Street and Winscott Road and was known as the "Marinda School." The school was named after one of the Willburn children, Marinda Willburn Snyder, who donated five acres of land for the building. During its early years, the community was known by the name of the school and its benefactor, "Marinda."

In 1876, James M. Benbrook petitioned the Texas and Pacific Railroad Company to place a train station along Mary's Creek near Marinda. The station was completed in 1880 and was named Benbrook Station after its chief petitioner. Eventually, people began associating the name of the station with the area, and the community became known as Benbrook.

The families of Benbrook slowly built their new lives and their new community. James Benbrook served as their justice of the peace for several years. With little more than a post office, a general store, and a cemetery, the people of Benbrook provided for themselves. Although the train station brought many people through the area, the population remained below 50 for nearly 100 years.

With photographs of the first families, their homes, and their descendants, this chapter provides a glimpse into the earliest days of Benbrook.

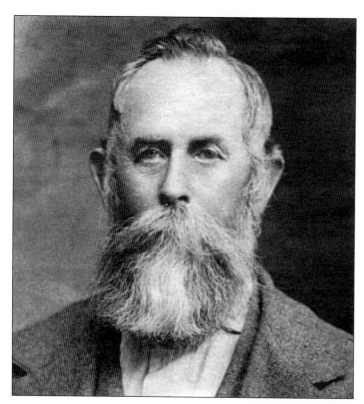

Originally from Illinois, James Monroe Benbrook settled on Walnut Creek in the Marinda area in 1876. He became known as "Squire" Benbrook because of his strong English heritage and courtly manner. Benbrook served as justice of the peace and on the cemetery board for much of the community's early years. He eventually became the namesake for the town when he lobbied the Texas and Pacific Railroad to build a station on land the company purchased from him. (Courtesy of City of Benbrook.)

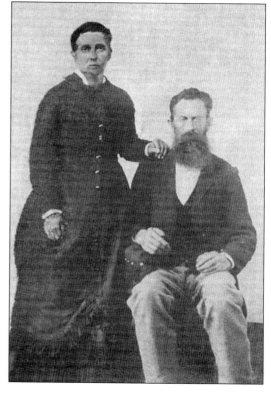

James M. Benbrook and his wife, Martha Metcalf Benbrook, moved to the area with their three children, Albert, James Jr., and Ida, in 1876. Martha died on July 8, 1885, and was buried next to her son Albert in the Benbrook Cemetery. Their graves can still be visited today. (Courtesy of City of Benbrook.)

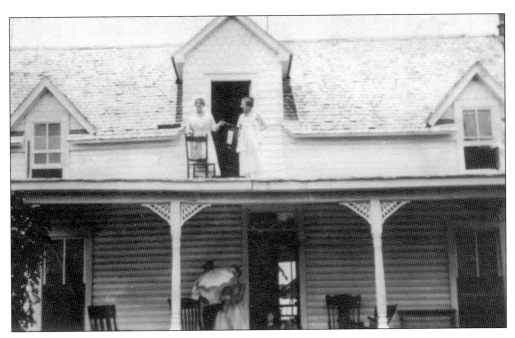

The Old Benbrook House, built in the Victorian style, was located on Walnut Creek east of the Marinda community. In 1887, after Martha's death, Benbrook married Louisa Ann Boaz, widow of Peter Boaz, and they moved into the house in 1891. James Benbrook died in 1907, and the family kept the home until 1921, when the land and home were purchased by M.N. Wallace. The Wallaces earned extra money during the Great Depression by using the home as a boardinghouse. (Both, courtesy of Mary Wallace Layne.)

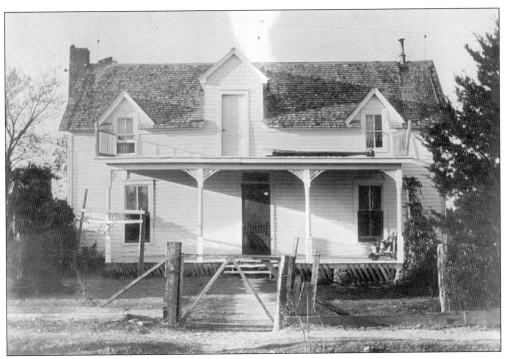

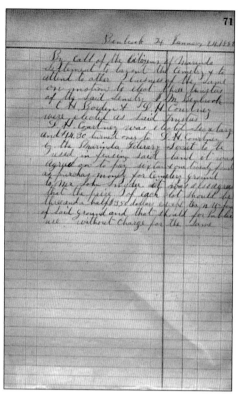

This is a page from the original Benbrook Cemetery Records Book, dated January 24, 1889. The notation states that the citizens of Marinda Settlement elected a board of trustees to look after the business of the cemetery. The community elected board members J.M. Benbrook and C.H. Borden with D.H. Courtney as secretary. Other orders of business included the handing over of money to the board by the Marinda Literary Society, the transfer of land from Dr. John Snyder to the board, and setting the price of each lot at $3.50. Although the cemetery was intended for use by the entire community, several area residents chose to maintain family cemeteries. In 1949, the US Army Corps of Engineers relocated graves from five family cemeteries to Benbrook Cemetery to clear the way for the construction of Benbrook Lake. The cemeteries were those of the Day, Hunter, January, Muhlinghausem, and Mustang families. Importantly, this page is also one of the earliest existing documents to refer to the community as Marinda. The cemetery records book is maintained by the city and underwent archival preservation in 2011. (Courtesy of City of Benbrook.)

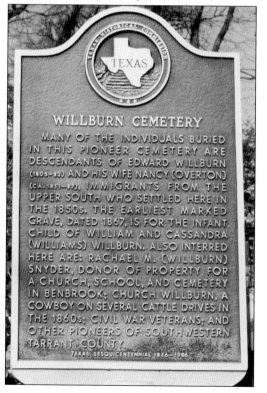

The Willburn Cemetery, a small family plot, contains about 15 graves with burials from 1867 to 1924. Many are descendants of Edward and Nancy Willburn, including Marinda Willburn Snyder. The Texas Historical Commission plaque marks the plot, located at 3720 Streamwood Road in what is now the Ridglea Country Club Estates subdivision. (Courtesy of City of Benbrook.)

This photocopy, dated December 10, 1885, is an expense log from the Benbrook Cemetery records book detailing start-up costs for the cemetery. Items include $16 for the purchase of land from Dr. John Snyder, materials and labor for a fence and gates, and costs of landscape maintenance. Fortunately, the amount collected for the lots more than paid for the start-up cost of the cemetery. The City of Benbrook currently maintains the Benbrook Cemetery. (Courtesy of City of Benbrook.)

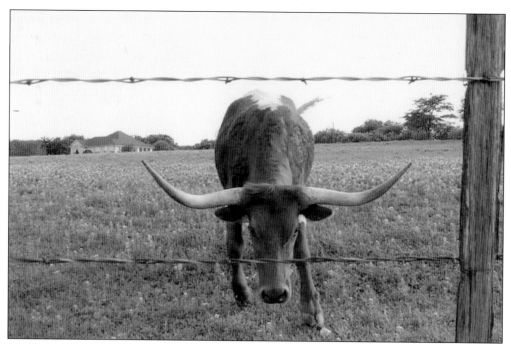

Longhorns have long been a symbol of life in Texas. Many of Benbrook's first settlers were heavily involved in raising and transporting cattle. The barbed wire in the photograph is likely original to the settlement. (Courtesy of Eugene.)

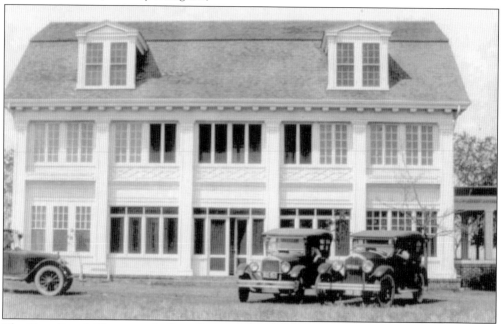

The Corn Ranch House was built in 1919 in far southwest Benbrook by James Corn, a rancher who owned more than 55,000 acres. The foreman of the ranch was John Stevens, for whom Stevens Road is named. The ranch was leased to the Wells Cattle Company in 1928, and Bill and Fleming Wells resided in the home. The house is still standing and is located just east of Benbrook Boulevard/US 377 South at the outskirts of town. (Courtesy of City of Benbrook.)

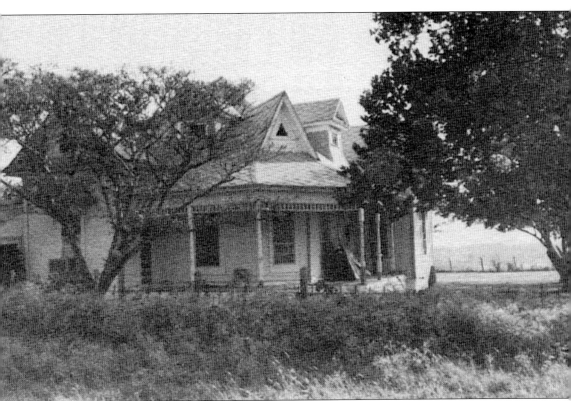

The Winfield Scott House was part of a large ranch located on Winscott-Plover Road, today known as Winscott Road. Winfield Scott was a prominent rancher and hotelier in Fort Worth but chose to keep a ranch on the outskirts of Benbrook. He actively worked the ranch until he retired in 1909 due to poor health. When Scott died in 1911, he left all his property to his wife, Elizabeth, and son, Winfield Jr. The sum of his properties were said to total over $43 million, making Winfield Scott Jr. the wealthiest 10-year-old in Tarrant County in 1911. (Courtesy of City of Benbrook.)

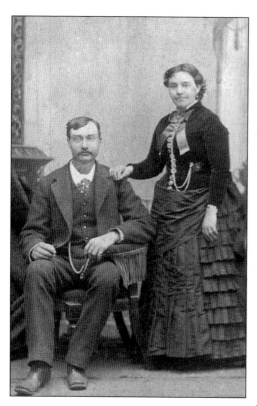

In the late 1800s, photographs were still a novelty and were taken for special occasions only. This photograph of James and Parlee Borden Childers was probably taken on their wedding day. James A. Childers was a ranch foreman for the Boaz Ranch until he purchased his own tract of land in 1893. Parlee Borden was the daughter of Calvin Borden, one of the earliest settlers in the Mary's Creek area and the first to receive land titles from the new State of Texas. (Courtesy of Cindy Childers Hughes.)

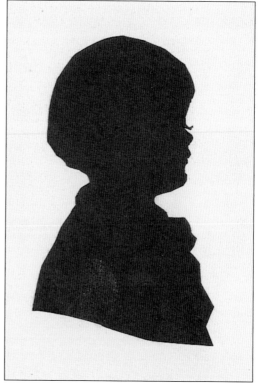

Silhouettes were a popular way for families in the 19th century to keep mementos of major events without the cost of photography. Although a silhouette would eventually refer to many different forms of profiles, the first silhouettes were hand-cut with scissors out of thin black card paper. The features of this child indicate that this is Beth Snyder McClellan, granddaughter of James M. Benbrook. (Courtesy of Robert Judson.)

The historic railroad bridge that spans Mary's Creek still stands today. Located in Z-Boaz Park, the bridge carried the Texas and Pacific Railroad Line leading to Benbrook Station from Fort Worth. The park is named after resident Z. Boaz, who donated the land to Fort Worth since Benbrook had no governmental body to accept such a donation. (Courtesy of Eugene.)

Named for an infant child who died prior to arriving in Texas, Mary's Creek was the main water source for settlers who came to the Benbrook area in the late 1800s. Today, although water is brought to houses through pipes from nearby water sources, many residents are familiar with Mary's Creek, which continues to run through the north side of Benbrook. (Courtesy of Eugene.)

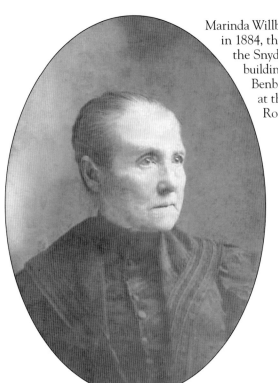

Marinda Willburn married Dr. John Snyder of Brownwood in 1884, the same year that land was transferred from the Snyder family to construct a school and church building. A portion of the land was also used for the Benbrook Cemetery, still in use today and located at the corner of Mercedes Street and Winscott Road. (Courtesy of Robert Judson.)

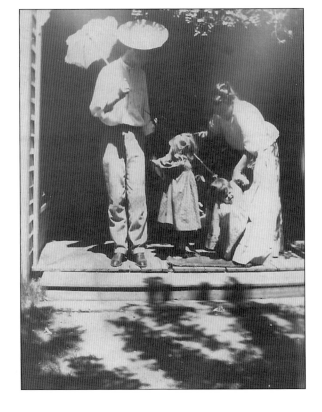

Dr. John Snyder and Marinda (Willburn) Snyder are on the porch of their home with their two small children. Marinda was the daughter of Benbrook's first settlers, Edward and Nancy Willburn. The Snyders would have seven children, one of whom, Edward "Ned" Snyder, would marry Ida Benbrook, daughter of Benbrook's namesake, James M. Benbrook. (Courtesy of Robert Judson.)

This is a photograph of Ned Snyder and Ida Benbrook Snyder on the night of their wedding on Christmas Eve in 1885. The event was most unique, as it was a triple wedding, the first in Tarrant County. The wedding couples, in addition to Ned and Ida, included E.C.W. "Church" Willburn and wife Pearce Barnett and Nannie Snyder and her husband, M.G. Wellls. (Courtesy of City of Benbrook.)

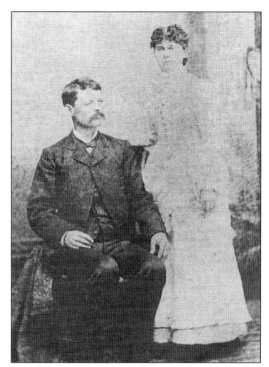

This house in Benbrook was owned by Dr. Edward "Ned" and Ida Snyder. The family also owned a home in Dr. Snyder's native Brownwood and travelled back and forth frequently. This Benbrook home burned down in the 1930s, and the family decided not to rebuild. (Courtesy of Robert Judson.)

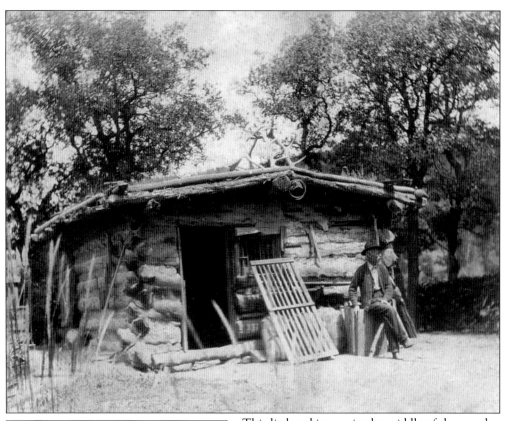

This little cabin was in the middle of the woods. While its location is now unknown, this cabin was known at the time as a place where men would go to hunt and possibly escape the hard work and duties of home. In this photograph, Ned Snyder sits outside the cabin looking eager to hunt game. (Courtesy of Robert Judson.)

Ned Snyder was a man of many interests; in addition to choosing his father's profession as a physician, he also raised and worked with cattle. His success in the cattle business allowed the family to keep two homes, one in Benbrook and one in Brownwood, as well as a full-time nanny. (Courtesy of Robert Judson.)

This photograph is of early Benbrook resident Nanny Wells. Wells was employed by the Snyder family for many years as their nanny. She cared for the children and most likely took care of many household duties. Wells no doubt became a second mother to the children. (Courtesy of Robert Judson.)

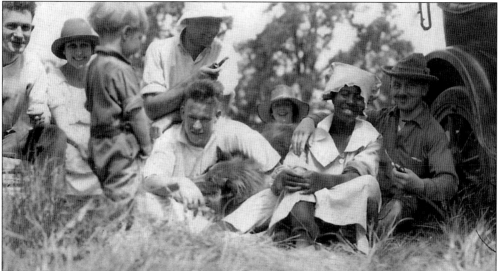

The Benbrook/Snyder families enjoyed the outdoors. The family would often take excursions to picnic, fish, and spend the day in each other's company. In this photograph, the family's nanny accompanied and took care of the children, but it is obvious she was considered a part of the family as well. (Courtesy of Robert Judson.)

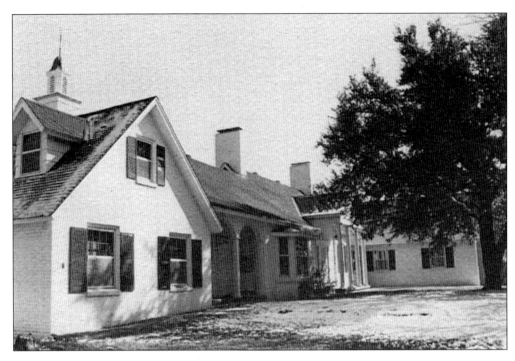

Dutch Branch Ranch was built in 1935. This ranch was home to Elliott and Ruth Roosevelt until 1944. Elliott, the second son of Pres. Franklin and Eleanor Roosevelt, was very influential in the community, where he was both a rancher and a radio station owner. Roosevelt employed an extensive staff to operate the ranch while he attended to other business endeavors in Tarrant County and elsewhere. The staff lived in the employee house, shown below. While most of the ranch is now located under Benbrook Lake, the ranch has maintained its legacy at the site of Benbrook's central park and athletic complex, Dutch Branch Park. (Both, courtesy of City of Benbrook.)

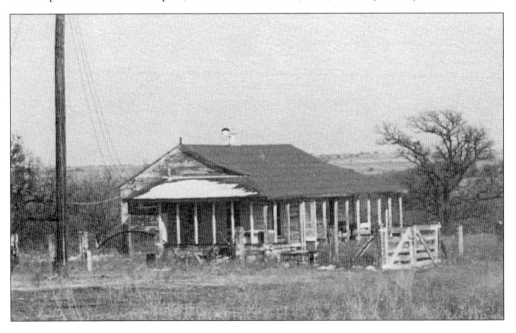

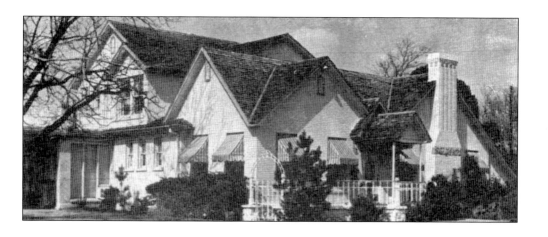

The Sproles House was built in 1935 by Ed Sproles, president of the Texas Motor Truck Transport Company. The homestead included the main home (pictured) as well as several outbuildings and served as the headquarters for the Sproles Ranch. While much of the original ranch is now under Benbrook Lake, the main house and some outbuildings have been preserved. Ed Sproles served as the first mayor of Benbrook in 1947 and on the Benbrook Common School District School Board. After the city's incorporation in 1947, several early Benbrook City Council meetings occurred in Sproles's home. The Sproles House was later used as a furniture store then abandoned and vandalized before being purchased and renovated by Dr. Jerry B. Dittrich, Benbrook's mayor as of 2011. The house, previously located on the corner of Benbrook Boulevard/US 377 and Sproles Drive, was relocated approximately 300 feet east of US 377 in 2008. (Both, courtesy of Dr. Jerry B. Dittrich.)

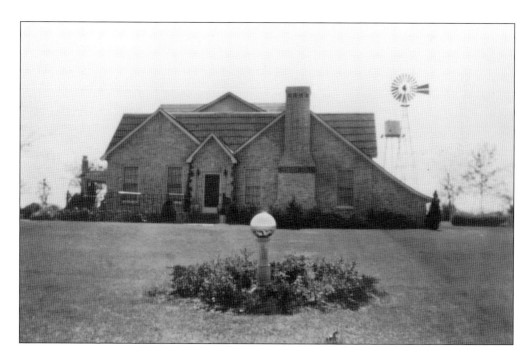

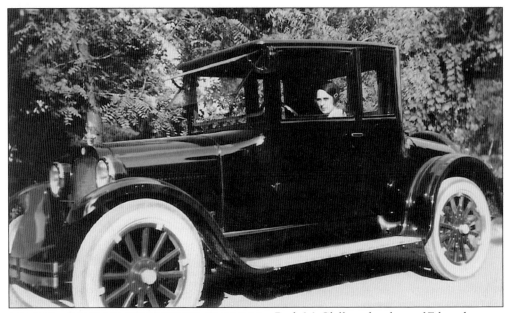

Beth McClellan, daughter of Edward and Ida Benbrook Snyder, poses inside their new steam car. Pictured in 1924, the vehicle was one of the last steam cars sold. Although steam propulsion was a competitor to the combustion engine, the creation of the key starter and the efficiencies of the Henry Ford assembly line drove down the cost and danger of the combustion-engine motor car, causing the eventual demise of steam cars. (Courtesy of Robert Judson.)

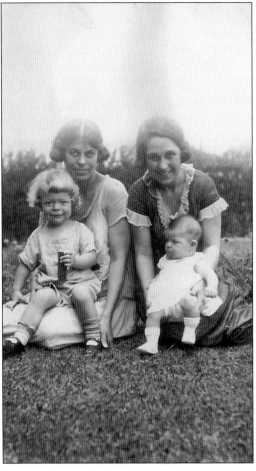

Francis and Beth, daughters of Edward and Ida Snyder, pose with their children in the front yard of the Snyder house. Although all of the Snyder children eventually married and moved away, they often gathered for family events. (Courtesy of Robert Judson.)

Dr. Edward "Ned" Snyder poses with granddaughter Mary Beth Judson outside the family home in Benbrook. Dr. Snyder of Brownwood married Ida Benbrook and was the grandson of first settlers Edward and Nancy Willburn. Ned and Ida had five children, Edward, John, Francis, Edith, and Beth. (Courtesy of Robert Judson.)

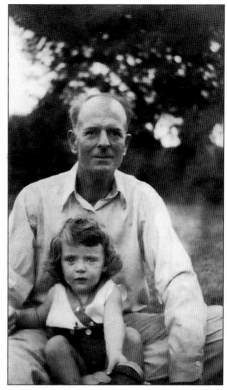

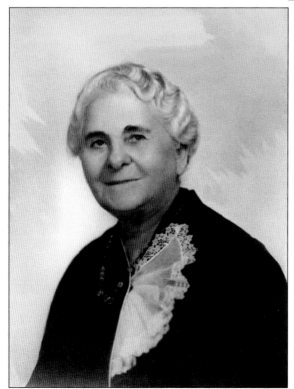

Ida Benbrook Snyder was the youngest daughter to the namesake of the city, James Benbrook. She married Dr. Edward Willburn Snyder, grandson of first settlers Edward and Nancy Willburn, on Christmas Eve, 1885. Ida died in 1953 at the age of 87. (Courtesy of Robert Judson.)

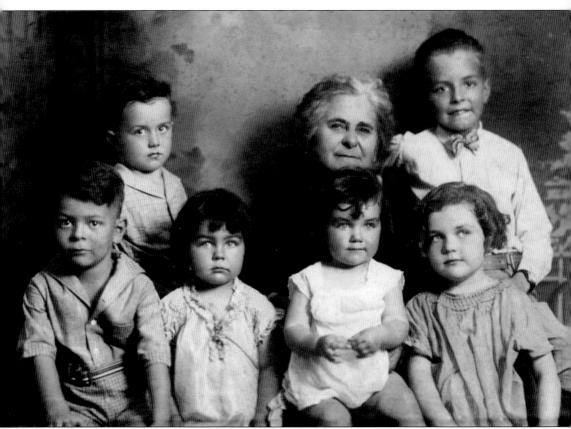

This photograph, probably taken in the 1930s, is of Ida Benbrook Snyder with all of her grandchildren. Ida had five children, all of whom married, and many more grandchildren were born after this photograph was taken. (Courtesy of Robert Judson.)

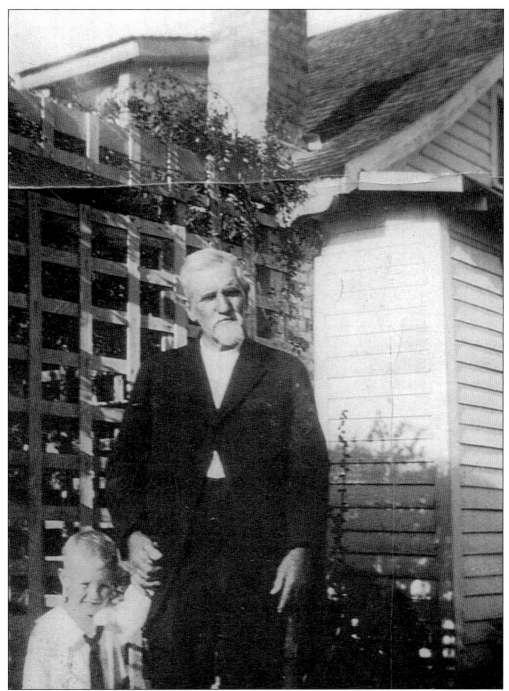

The Childers family has played an important role in Benbrook's history since its beginnings. James A. Childers is with his grandson and namesake James A. Childers, age four, outside the home of Jones and Jeanette Childers in the 1920s. All three generations of the Childers family were prominent and active citizens in Benbrook, even before incorporation. (Courtesy of Cindy Childers Hughes.)

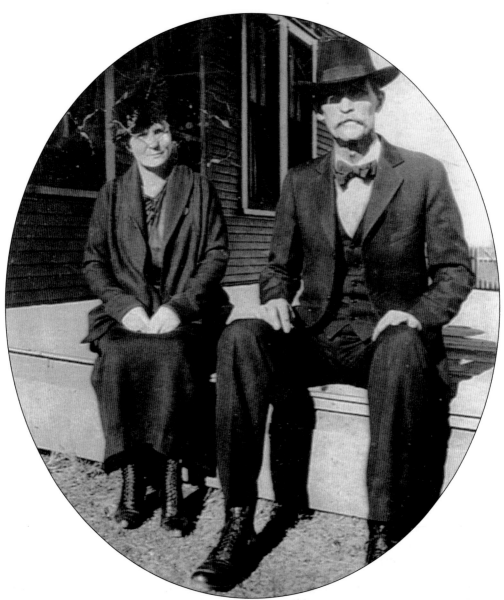

James A. Childers, born in 1855, lived to be 72 years old. This photograph shows Childers and his wife in the early 20th century on the front porch of their Victorian-style home, which was located near the corner of Winscott Road and Old Benbrook Road. (Courtesy of Cindy Childers Hughes.)

Two

EDUCATION AND RELIGION

When the first settlers arrived in the Mary's Creek area in the 1850s, the first order of business was to build a church and schoolhouse. Because the population was so small, their needs were met by building a single-room, double-use concrete building. The building soon collapsed and was replaced by a wooden building lovingly referred to as "Old Rawhide," which burned down in 1879.

After the Civil War, in 1880, a third building was constructed on land donated by Marinda Snyder, daughter of first settlers Edward and Nancy Willburn. This building was a two-room brick structure that once again served as both the Methodist church and the school. It was called the Marinda School and was located near the intersection of Mercedes Street and Winscott Road. During this time, the building was a meeting place for nearly every community event. The site reportedly included a cemetery, established in 1885, which most likely was the beginning of the present-day Benbrook Cemetery. The community was known as Marinda in its early years.

In 1884, the Marinda School and Church was relocated again to the intersection of Winscott Road and Old Benbrook Road (where the present-day Weatherford International building is located), again on land donated by Marinda Snyder. The school was renamed Benbrook School in 1885.

In 1912, Benbrook School was rebuilt as a two-room redbrick structure that served the community from 1912 to 1935. In 1935, a new building replaced the old redbrick school. This building was a four-room structure constructed of flagstone. It was used from 1935 until 1953, when the current Benbrook Elementary School, located on Mercedes Street, began the 1953 school year.

The families that lived north of the (eventual) railroad along Mary's Creek also built a school and church building known as Chapin School, named after early settler I.H. Chapin.

In 1929, the Methodist church began constructing its first building independent of the Benbrook School. As the population grew, so did the number of churches in the area. In addition to the Methodist church, Benbrook also had well-attended Baptist and Church of Christ congregations.

The following pages depict some of the community's religious and educational institutions.

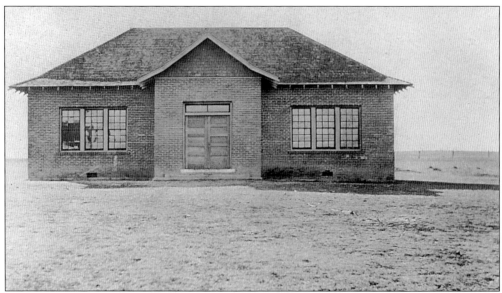

Financed by bonds, this version of the Benbrook School was built in 1912. The redbrick structure had two rooms, one of which had a stage for programs and a room divider that could be opened up to accommodate community events. In 1912, there were about 75 students taught by a single teacher. A second teacher was hired in 1918 to more adequately instruct the students at Benbrook School. (Courtesy of Mary Wallace Layne.)

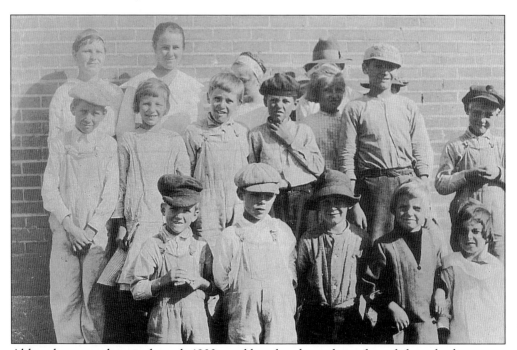

Although most students in the early 1900s would not be educated past the eighth grade, the citizens of Benbrook always placed great importance on education. This class photograph is evidence of Benbrook School's importance to the community, since photographs were expensive to produce at the turn of the century. (Courtesy of Mary Wallace Layne.)

Children play in the yard of the redbrick schoolhouse during the 1916–1917 school year. Benbrook children were educated in this building from 1912 to 1935. The grounds included an outhouse and a well for drinking water. All students were required by law to bring a drinking cup to school every day. The students not only studied but also played at the school. The play area consisted of a baseball diamond and basketball backboards in addition to a tether pole. The students raised money for outdoor play equipment by charging a 5¢ admission fee to attend school plays. When the school became overcrowded, many former Benbrook School students became teachers to help educate the current students. (Both, courtesy of Mary Wallace Layne.)

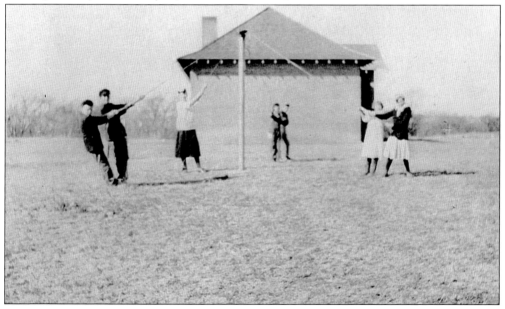

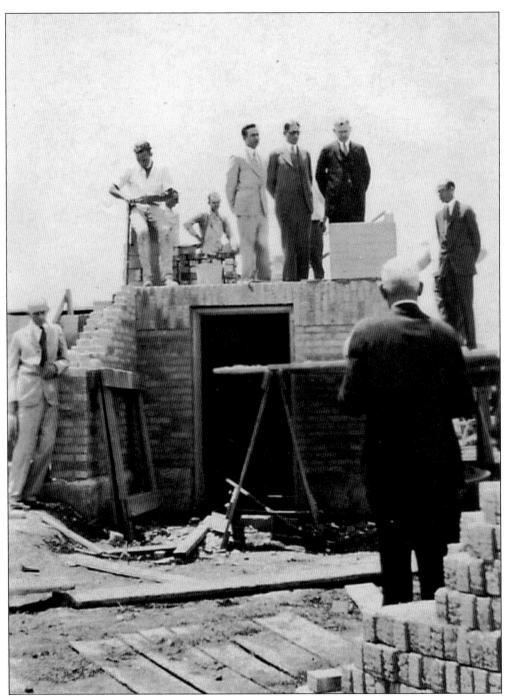

In the late 1920s, there was a great need for a new church building in Benbrook. A fundraising campaign began, led by Mrs. N.E. Wallace, known as "Mother Wallace." Within a week, $2,100 had been collected. The cornerstone of the Benbrook United Methodist Church, laid in May 1929, was inscribed with the names of the major contributors. Bishop H.A. Boaz, future president of Southern Methodist University, presided over the ceremony, as seen in this photograph. (Courtesy of Mary Wallace Layne.)

Bernice Wallace and Frank Wallace Jr. are sitting on the steps of the Benbrook United Methodist Church in 1930, just after construction had been completed. Built in the Greek Revival style, the church included a sanctuary, classrooms in the basement, and its own electric light plant. The building was used by the Benbrook United Methodist Church until 1957, when the church moved to its current location on Bryant Street. (Courtesy of Mary Wallace Layne.)

Taken in 1934, this is the congregation picture of the Benbrook United Methodist Church. The church was under the pastoral care of minister Franklin Ray, standing fifth row center in this photograph. Beginning the following year, in 1935, the church supported its programs by hosting a large dinner party twice a year, prepared by the women of the church. (Courtesy of Cindy Childers Hughes.)

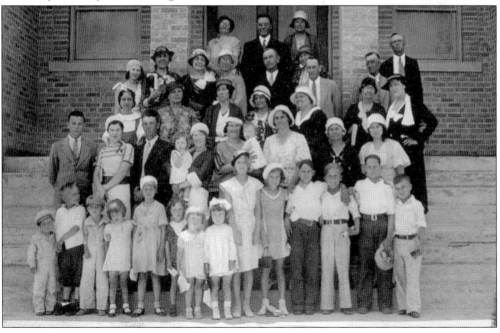

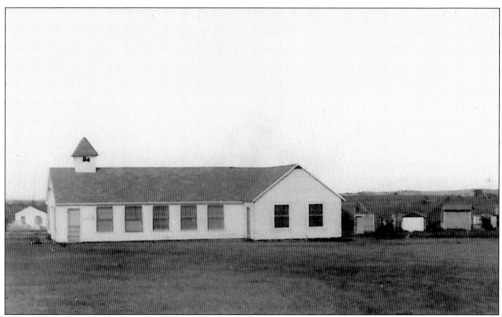

This photograph shows the Benbrook Baptist Church, located in the general area of present-day Goliad Street, close to the now-existing frontage road of Loop 820. In July 1954, due to theological differences, 53 members left the church to begin their own, later becoming First Baptist Church of Benbrook. They would meet in the abandoned Benbrook School until they could construct their own building. (Courtesy of First Baptist Church of Benbrook.)

These are the original buildings of the First Baptist Church of Benbrook, which split from Benbrook Baptist Church in 1954. The congregation received a $20,000 construction loan from the Baptist General Convention of Texas. First Baptist Church of Benbrook still meets in these buildings, located on the corner of McKinley and Davidson Streets, but has added other facilities over the years. (Courtesy of First Baptist Church of Benbrook.)

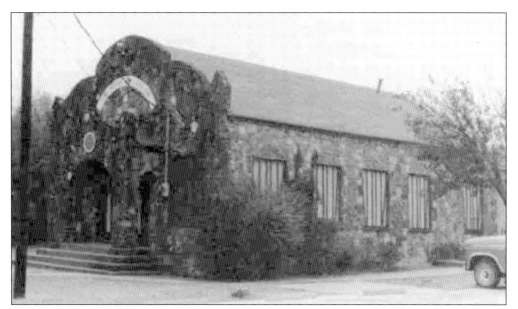

Benbrook Church of Christ was constructed in 1933 by stonemason P.A. King of Aledo. Local families, including the Pearcy family, who owned The Stand convenience store on Benbrook Boulevard/US 377, helped build the church. The building is still standing and is currently the American Legion Paul Mansir Post 297. The Legion hall is named after Vietnam War veteran Paul Mansir of Benbrook, who died in combat on September 11, 1967. (Courtesy of Carol Pearcy Shour.)

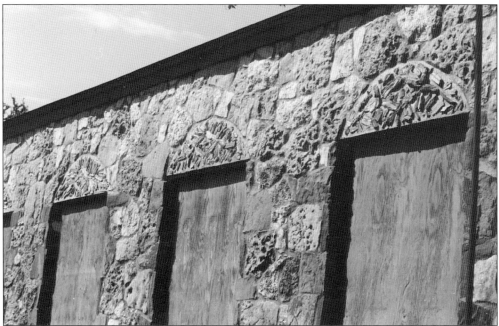

While the men completed most of the masonry work involved in constructing the Church of Christ, the women made sure to add a decorative touch. Church members Carrie Green, Cassie Stalland, and Reba Pearcy crafted the inlaid rock decorations above the window frames. (Courtesy of Carol Pearcy Shour.)

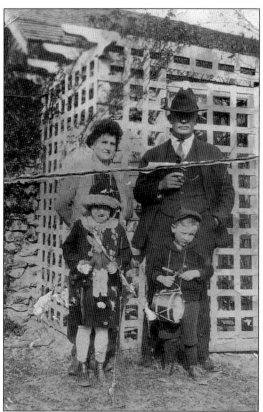

Jones and Jeanette Childers, along with their two children, Jim and Martha, are dressed in their Sunday best outside their home located on Winscott Road. Jones, the first police constable of Benbrook, was also an active member of the Benbrook United Methodist Church. (Courtesy of Cindy Childers Hughes.)

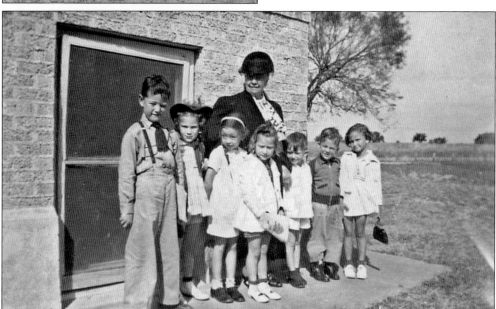

The Sunday school class of Mrs. N.E. Wallace is pictured at the Benbrook United Methodist Church in 1940. Known to all in Benbrook as "Mother Wallace," she taught first grade Sunday school for nearly 30 years. Her daughter, Ann Wallace, taught in her place when Mother Wallace became too ill to continue teaching. (Courtesy of Mary Wallace Layne.)

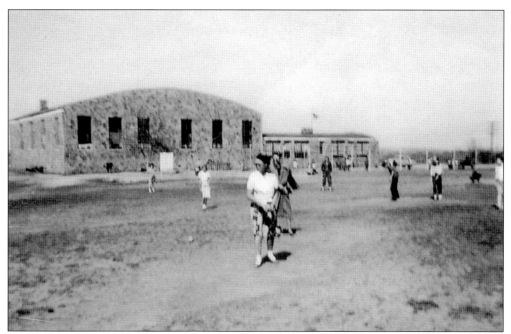

This flagstone version of the Benbrook School was in operation from 1935 to 1953. The building was abandoned in the 1950s, and the First Baptist Church used it for services from 1954 to 1955. Today, the arched wall of the gymnasium can still be seen on the south side of the Weatherford International building, as it was preserved and incorporated into the new facilities. (Courtesy of First Baptist Church of Benbrook.)

"Womanless Wedding" plays were common throughout the South in the 20th century and were often fundraisers for a local charity. Benbrook's version of the play was put on by the Lions Club around 1950 and included many prominent citizens, including A.R. "Pop" Cartwright and first mayor Ed Sproles. Community events such as this play were held in the gymnasium of the flagstone Benbrook School. (Courtesy of Cartwright family.)

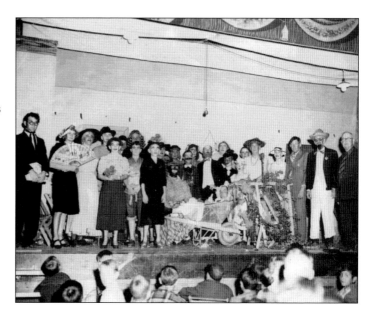

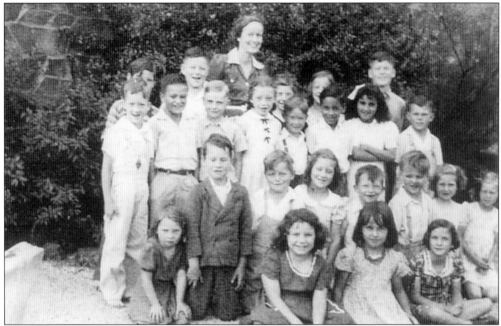

This photograph shows the 1942 class of first- through third-graders at Benbrook School with teacher Marvel Boba Wallace, wife of Frank Wallace. Marvel was also the librarian and opened the library one afternoon a week to the general public. All grades were taught in the same school building, and the school employed three teachers. (Courtesy of Mary Wallace Layne.)

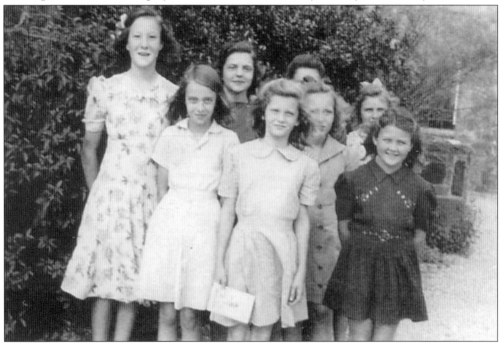

By the 1940s, Benbrook School had grown large enough to separate the students into upper and lower classes. This is a photograph of the Upper Girls Class of 1942 posing outside the rock schoolhouse. (Courtesy of Mary Wallace Layne.)

Chuck Atkinson moved to Benbrook in 1959. He opened the Sailing Center on Lake Benbrook in 1969. His parents settled in Benbrook in the 1970s. Mr. and Mrs. Atkinson, along with Chuck and his sister, head to church to attend the Easter service at Benbrook's Western Hills Baptist Church. (Courtesy of Chuck Atkinson.)

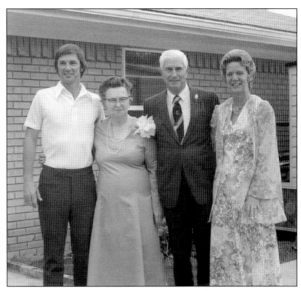

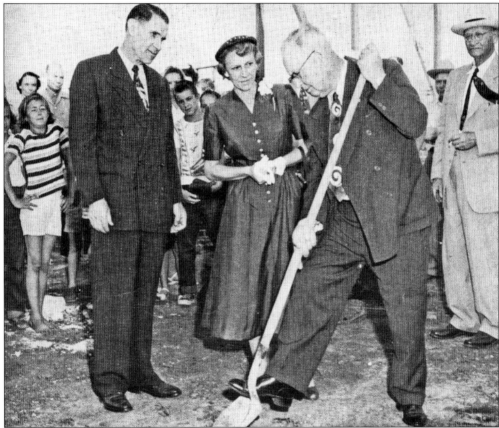

This photograph appeared in the 1954 Benbrook School yearbook. The ground-breaking ceremony included Tarrant County Schools superintendent Bob Stowe (left), Mayor Ed Sproles (with shovel), and alderwoman Grace Cozby. Mrs. Cozby was a very active citizen of Benbrook and donated the land for the school, currently Benbrook Elementary School. (Courtesy of Jess Jordan.)

This is a 1983 photograph of Benbrook Elementary School in its current location. The school is part of the Fort Worth Independent School District and is one of two elementary schools in Benbrook. Although the exterior of the building hasn't changed much since initial construction, the interior has undergone extensive remodeling. (Courtesy of Robert Cook.)

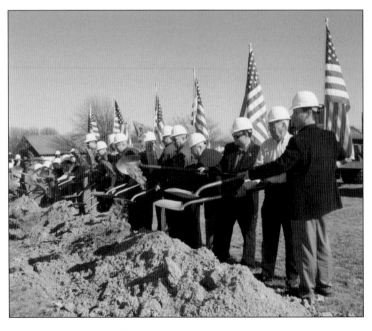

Three Fort Worth Independent School District campuses are within the city limits of Benbrook: Benbrook Elementary, Westpark Elementary, and Western Hills High School. A fourth campus, Benbrook Middle School, opened in the fall of 2011. This photograph shows the Benbrook City Council at the January 2010 ground-breaking ceremony for Benbrook Middle School. (Courtesy of City of Benbrook.)

Three

CARRUTHERS FIELD

During the early years of World War I, the Royal Canadian Flying Corps was invited to establish its pilot training fields in Texas because of its milder climate. After inspecting sites in Dallas, Fort Worth, Austin, Wichita Falls, and Midland, three sites were established in 1917 in the Fort Worth vicinity: North Fort Worth, Everman, and Benbrook. This became known as the "Flying Triangle."

The Royal Canadian Flying Corps used the fields from October 1917 to April 1918, when they were turned over to the US Army.

Taliaferro Field No. 3, later renamed Carruthers Field, was located south of Mercedes Street in what is now the Benbrook Lakeside Addition. Most of the 34 buildings and hangars were located in an area generally bounded by Mercedes Street on the north, Winscott Road on the east, Cozby North Street on the south, and Walnut Creek on the west.

As aircraft became commonplace in Benbrook, so did plane crashes. In fact, Carruthers Field held the record for the most plane crashes of any Canadian air training field. Many pilots were trained at Carruthers Field, and a few died there too. Some of those lost in Carruthers Field are buried in Greenwood Cemetery in Fort Worth, where their graves can be visited today.

One of the most notable pilots at Carruthers Field was Vernon W. Blyth Castle (Castle being a stage name), whose death shocked not only Benbrook but the nation. Part of the famous Vernon and Irene Castle dance team, Castle and his wife introduced the tango to the United States in 1913.

When the United States entered the war, the field was renamed Benbrook Field and served to train American pilots as well. The training field and its buildings were razed in the 1920s.

After the war, airfield land was purchased from the military and turned into a dairy farm. Although the legacy of the airfields is well preserved through the photographs in this chapter, there is virtually nothing left of the physical footprint of the airfield in Benbrook.

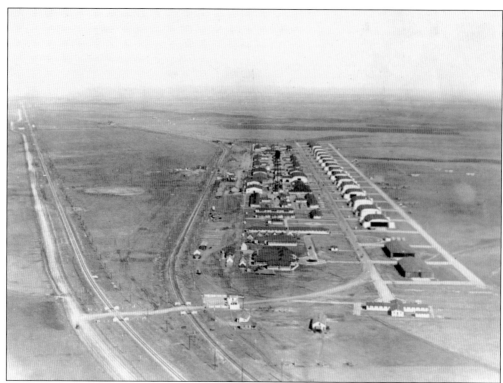

These aerial photographs of Carruthers Field show the scale of the military installation. Carruthers Field contained nearly 40 buildings, including six mess halls, the commanding officer's quarters, five commissioned and non-commissioned officer's quarters, six cadet barracks, a hospital, a fire hall, an administration building, a bakery, several shops for building, testing, and repairing airplanes, and hangars. The citizens of Benbrook, especially the children, were very welcoming to the cadets. Children would often help push the planes onto the runway. Carruthers Field, originally named Taliaferro Field No. 3, was renamed in honor of Cadet W.K. Carruthers, who was killed at Hazelhurst Field on Long Island when he was struck by a revolving propeller in June 1917. (Both, courtesy of Benbrook Public Library.)

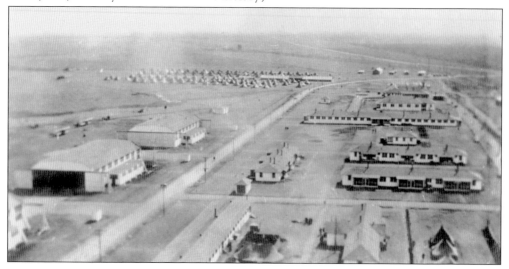

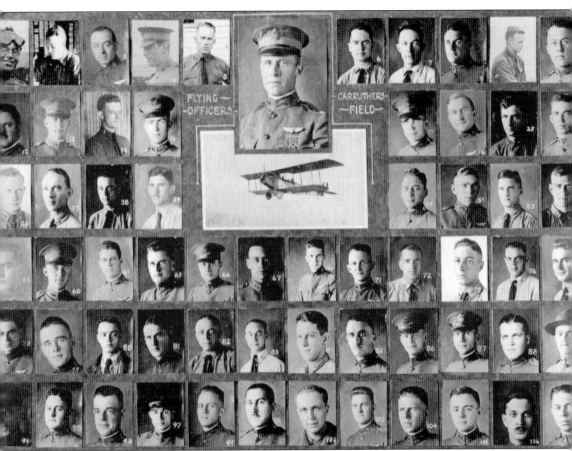

Serving as a flight officer was a dangerous and demanding job. Officers were often asked to train new cadets immediately after their own flight school experience or straight from combat. Nearly 40 cadets and officers died in training accidents at the three Fort Worth area fields. Eleven are interred at Greenwood Cemetery in Fort Worth. (Courtesy of Benbrook Public Library.)

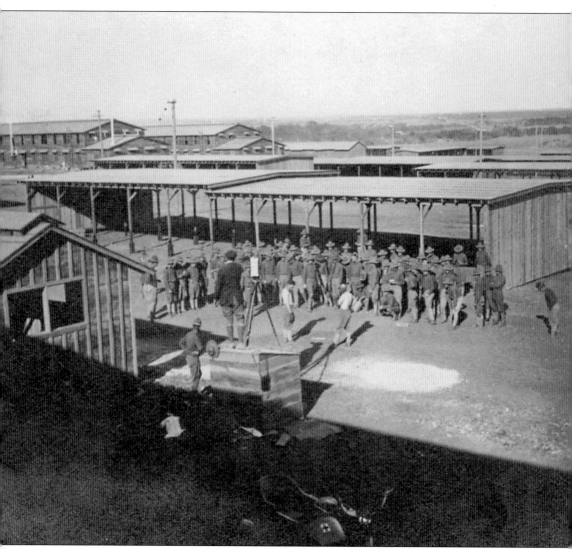

When newly enlisted cadets arrived at an airfield, they were quickly initiated and given gear. Because the need for pilots and mechanics was urgent upon entering the war, most cadets received expedited and very rudimentary flight training in the United States and would hopefully receive more advanced training after arriving in Europe. Perhaps this expedited training was the reason for so many crash landings at Carruthers Field. (Courtesy of Robert Judson.)

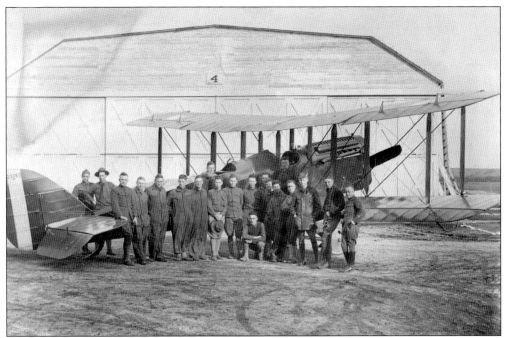

This photograph shows a training unit in front of Hangar 4 at Carruthers Field with its prized JN-4 airplane. The JN-4, known as the Jenny, was the primary training plane for the Allied forces during World War I. The twin-seat, dual-control biplane allowed the student to sit in front of the instructor. With a 90-horsepower engine, the plane reached top speeds of 75 miles per hour. (Courtesy of Benbrook Public Library.)

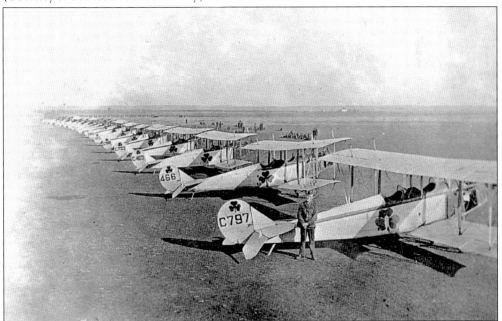

The Clover Squadron readies its planes for inspection on February 8, 1918, at Carruthers Field. This important inspection ensured that both the cadets and the airplanes were prepared for flight. (Courtesy of Benbrook Public Library.)

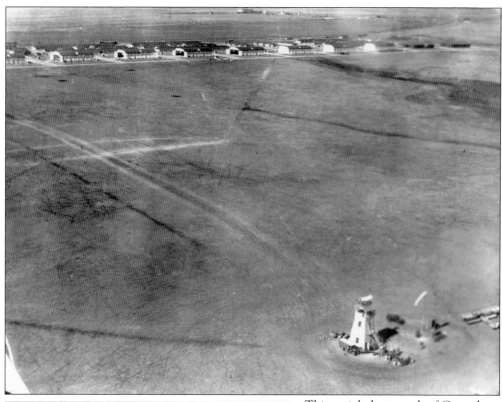

This aerial photograph of Carruthers Field includes both the control tower and the wind sock. There is almost no evidence of the airfield in Benbrook today, which is surprising given its breadth. (Courtesy of Benbrook Public Library.)

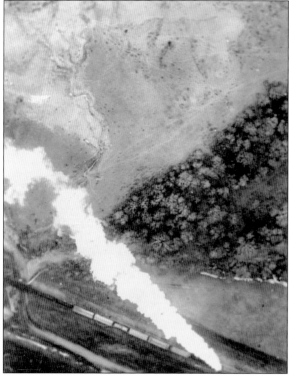

This photograph was taken by a cadet from his aircraft while stationed at Carruthers Field. The train had likely just left or was about to arrive at Benbrook Station along the Texas and Pacific Railway Line. (Courtesy of Benbrook Public Library.)

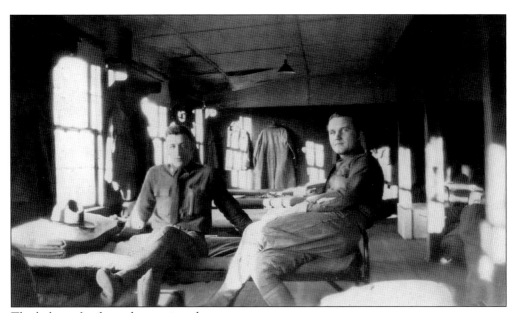

The lodging for the cadets stationed at Carruthers Field was modest, with many cadets living in one-room barracks. The barracks could get quite hot in the summer, but Benbrook was chosen for the airfield because of the mild climate that allowed year-round training. (Courtesy of Benbrook Public Library.)

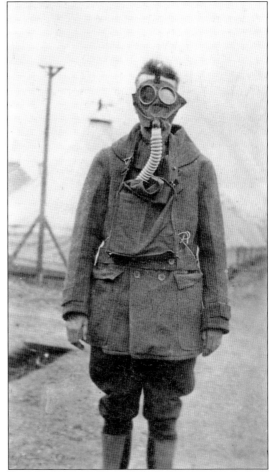

All soldiers, including the Royal Canadian Flying Corps, were required to use a military-issued gas mask for training exercises. The first masks, shown here, were very useful and prevented many fatalities during the war. (Courtesy of Benbrook Public Library.)

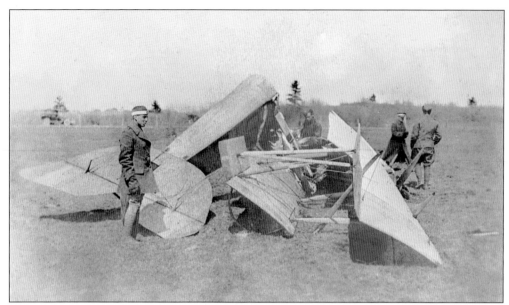

This cadet was one of the lucky ones. Although he was unable to safely land his aircraft, he survived the crash unscathed. He was required to stand by his aircraft until a supervising officer could get to the site to document damages. (Courtesy of Benbrook Public Library.)

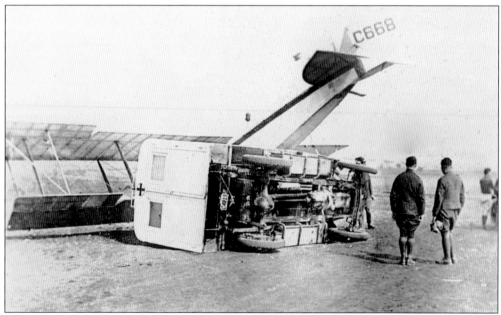

Carruthers Field experienced the most airplane crashes of any Canadian flight training field. In this incident, the plane was unable to avoid an ambulance, probably on its way to check on the fate of a different crash site. (Courtesy of Benbrook Public Library.)

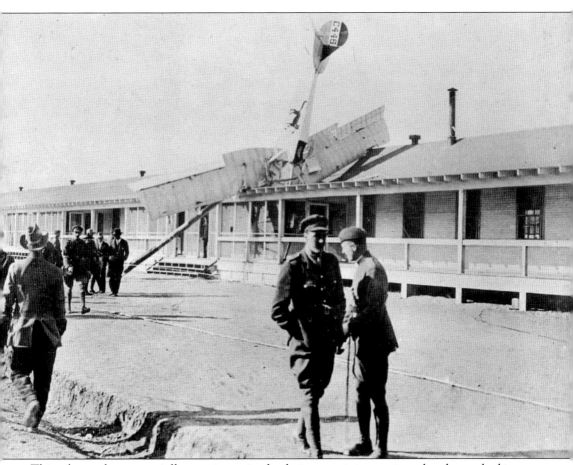

This pilot made an especially egregious mistake during a training session when he crashed into one of the training field buildings. Both military officials and civilians take in the scene. (Courtesy of Benbrook Public Library.)

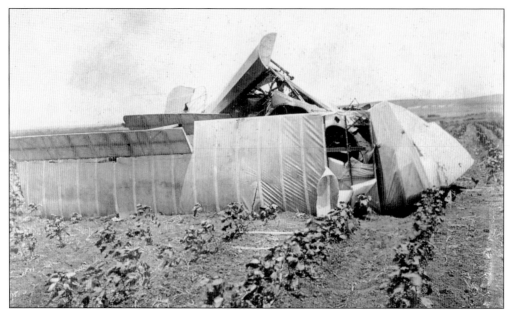

This plane experienced a collision with a crop field in Benbrook in 1918. The air training field was surely a unique and exciting distraction for a small, rural community like Benbrook. (Courtesy of Benbrook Public Library.)

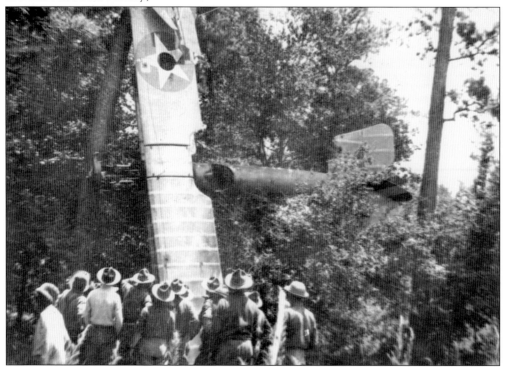

While many of the accidents at Carruthers Field occurred during landings and take-offs in areas clear of trees, the pilot in this photograph could not avoid this crash in a forested area, probably adjacent to the airfield. Note the onlookers who have come to observe the crash site. (Courtesy of Benbrook Public Library.)

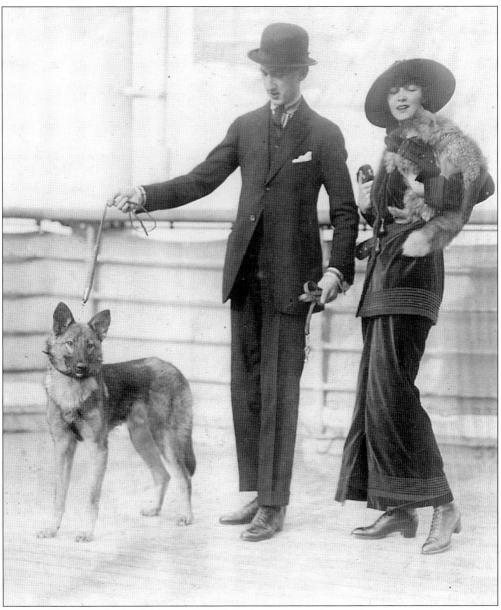

Born in Norwich, England, Vernon W. Blyth Castle was a famous dancer and performer who received his pilot's license to serve in the Royal Flying Corps (RFC) during World War I. Shown with his wife, Irene, Castle quickly moved up the ranks of the RFC and was stationed at Carruthers Field as a pilot instructor in 1917, after receiving a Croix de Guerre medal for taking down two German planes. (Courtesy of Benbrook Public Library.)

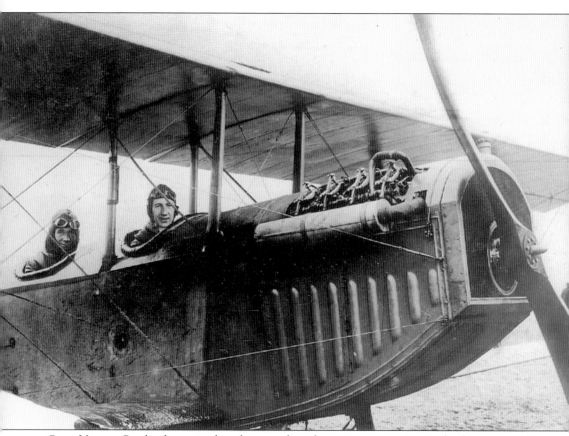

Capt. Vernon Castle, shown in this photograph with a trainee, is sitting in the front seat of his Jenny. It was unusual for a trainer to sit in the front, because it was the most exposed seat and the occupant was more likely to suffer an injury in accident. Castle preferred to sit in the front, despite the danger. In February 1918, an unavoidable collision occurred on Carruthers Field. Castle lost his own life but saved both the trainee pilot and Castle's pet monkey, Jeffrey, who was always a companion on his flights. (Courtesy of Benbrook Public Library.)

Vernon Castle's untimely death made national headlines. Castle was laid to rest near his home in New York. The local procession was one of the biggest events in Tarrant County at the time. A biographical Hollywood movie would later be filmed depicting Castle's life. *The Story of Vernon and Irene Castle* was released in 1939 and directed by H.C. Potter. The film's stars included Fred Astaire, Ginger Rogers, Edna May Oliver, and Walter Brennan. (Both, courtesy of Benbrook Public Library.)

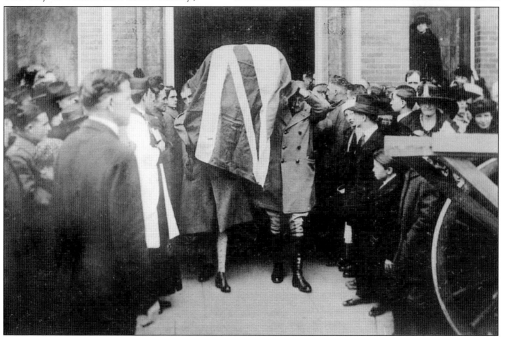

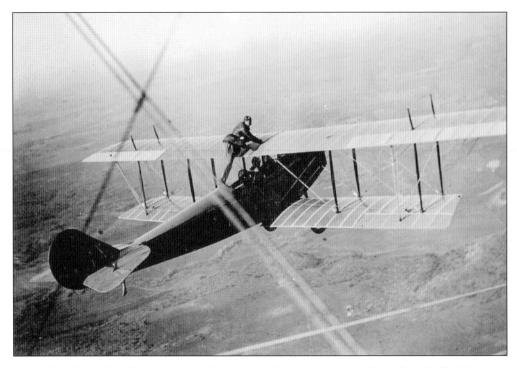

Second Lt. Omer Locklear was a local celebrity while a trainer at Carruthers Field. Native to nearby Greenville, Texas, Locklear was a daredevil, often climbing the wings and riding on the fuselage of his plane. When the war was over, Locklear tried to remain in the military as a recruiter but left when he realized that his flight skills were much more impressive and entertaining. After creating his own barnstorming show, Locklear and his colleagues were lured to California, where they starred in flight movies. Locklear died while making his second film, the *Skywayman*, in August 1920 and is buried in Fort Worth. (Both, courtesy of Benbrook Public Library.)

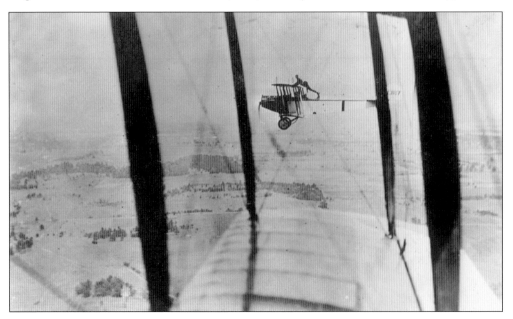

Four

BENBROOK BECOMES A CITY

Although Benbrook is one of the oldest communities in Tarrant County, it is one of the youngest incorporated cities. For nearly 100 years, the small Benbrook community sat quietly on the edge of Tarrant County as neighboring Fort Worth went from a sleepy outpost to a bustling town. Those living in Benbrook resisted becoming part of the bigger city.

On November 17, 1947, wishing to maintain their own identity, the people of Benbrook voted 25-0 to incorporate as a village. The citizens of Benbrook quickly acted to create a governing body and a volunteer fire department. They also outlawed taverns and the sale of alcohol and aided in the construction of Benbrook Lake.

Since incorporation, city services increased to meet the needs of an ever-growing population. In 1975, city council decided the burgeoning municipal complex, which housed city hall, the fire department, and the police station, was insufficient. They hired an architect to construct the city hall and the police station on a five-acre site donated by Billy Joe Smith.

The fire department remained in the older building until 1980, when the city built a new state-of-the-art facility on Mercedes Street. In 1987, the police department moved into its current building, also located on Mercedes Street.

The city's comprehensive plan aims to continue to provide planned, sustainable, and desirable development. With city services highly ranked in national surveys, citizens can expect to remain proud to call Benbrook home.

Ed Sproles was elected the first mayor of Benbrook in 1947 and served one term. The first aldermen included J.A. Childers, Grace Cozby, M.N. Wallace, W.J. Nolte, and D.I. Sessums. (Courtesy of City of Benbrook.)

This headshot of J.A. "Jim" Childers is probably from his first election for a spot as city alderman in 1947. Childers was a prominent local businessman who owned a grocery store, filling station, café, service route, and gravel company. He was also instrumental in creating the Benbrook volunteer fire department and the Benbrook Water Authority. (Courtesy of Cindy Childers Hughes.)

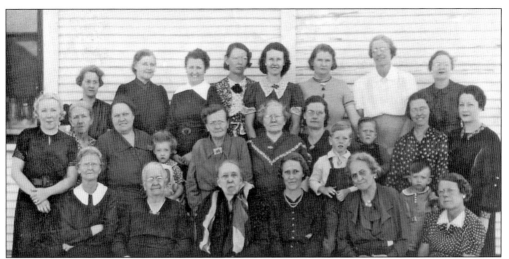

Taken in 1936, this is a photograph of the Women's Home Demonstration Club of Benbrook. In rural areas, a home demonstration agent would provide instruction on many of the necessities of rural life, including canning and mattress fabrication. The program was funded through collaboration between the US Department of Agriculture and the State of Texas because of the Smith-Lever Act of 1914. Gathering in homes and churches around town, the meetings were as much social events as educational ones. (Courtesy of Mary Wallace Layne.)

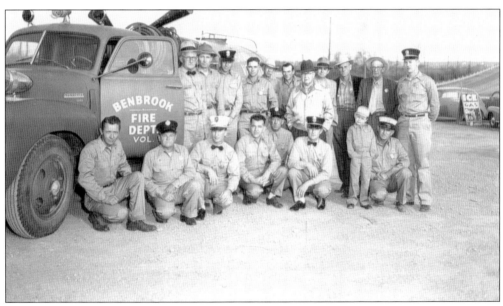

A fire nearly consumed the nearby Wheatland community, forcing ranchers to fight the fire with cattle sprayers. This near-tragedy spurred the men of Benbrook to form a volunteer fire department. Serving on a volunteer basis, many men signed on to protect the community, including A.R. Cartwright, D.I. Sessums, Dick Wallace, H.S. "Doc" Duncan, Ed Sproles, Joe Skinner, J.B. Bowles, Jim Childers, Aubrey Cartwright, and several others. (Courtesy of Cindy Childers Hughes.)

Jones Childers, son of rancher James A. Childers, served as Benbrook's first constable. Constables are one of the oldest forms of law enforcement. Childers's role was to enforce the laws of both the county and the City of Benbrook. (Courtesy of Cindy Childers Hughes.)

Benbrook's first fire truck was a Chevrolet 6500 donated by Ernest Allen Chevrolet. The water tank was donated by Ed Sproles. Pictured here is the first fire chief, Jim Childers. The city kept the truck behind the police department building. The fire department grew quickly and soon required its own building. (Courtesy of Cindy Childers Hughes.)

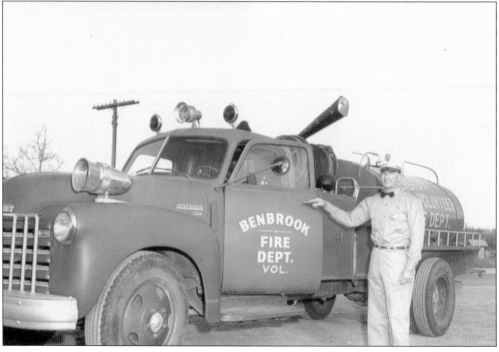

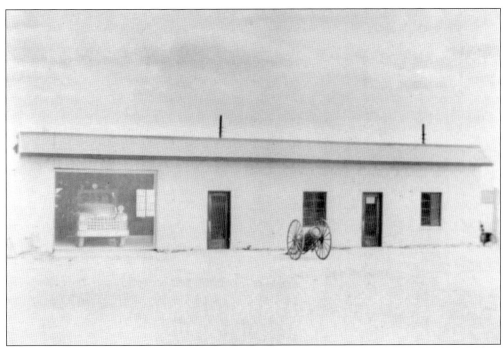

This is a 1953 photograph of the original Benbrook Fire Station. Built in 1950, the building quickly required an addition as the community's needs grew. The building also housed the police department and, later, the Benbrook Library. (Courtesy of Joanne Bowles Eason.)

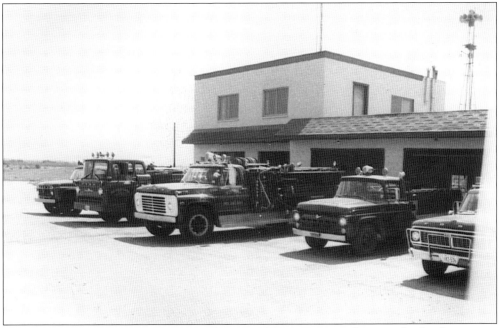

This photograph shows the additions to the original fire station. At the time, the fire department was still all-volunteer. Volunteer firefighters had plectrons, or red telephones, in their homes to alert them when an emergency required their services. Volunteers kept their clothes and boots at the end of their bed to respond as quickly as possible. (Courtesy of City of Benbrook.)

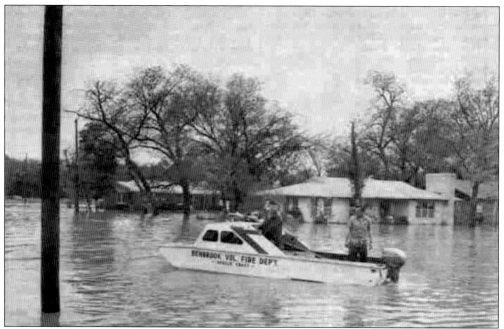

Bill Trammell and others assist with search and rescue during the 1949 Fort Worth flood. The impoundment of Benbrook Lake greatly reduced the flood risk in the area. The Benbrook Fire Department still keeps a rescue boat available for lake rescue and in the event of flooding. (Courtesy of Benbrook Fire Department.)

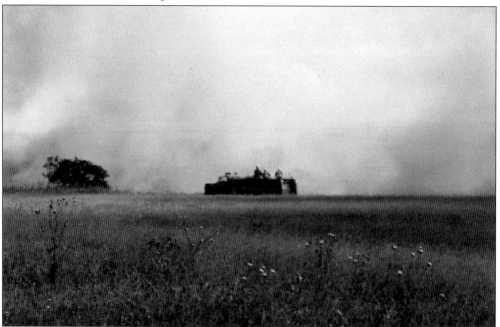

Grass fires have always posed a threat to cities and towns on the prairies of Texas. At the time of this photograph, the fire department was still an all-volunteer organization. Grass fires are unpredictable and very dangerous, but the men and women of the Benbrook Fire Department frequently put the safety of the community before their own lives. (Courtesy of Benbrook Fire Department.)

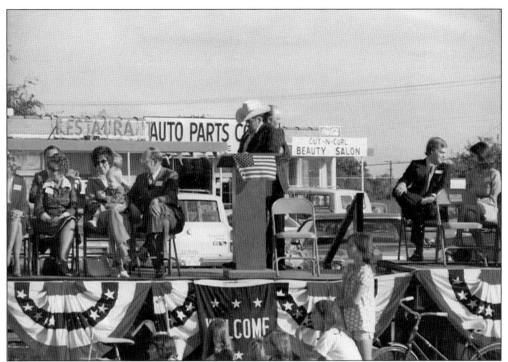

The Benbrook community often held parades along US 377 (Benbrook Boulevard). This parade celebrates the Miss Flame Pageant, a fundraiser held annually by the fire department. By the 1960s, Benbrook's population had increased and parades along this stretch of highway were a popular event. (Courtesy of City of Benbrook.)

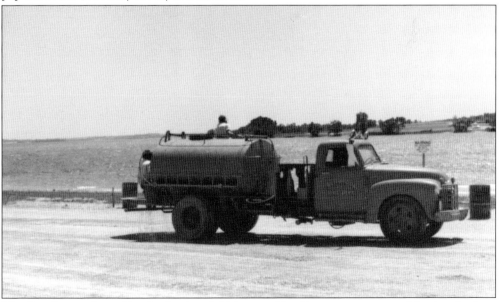

The first fire truck used by the Benbrook Volunteer Fire Department was used by the city for a couple decades. This photograph, taken in 1977, shows the truck at Benbrook Lake. Although it may not have been the primary truck by this time, the truck remained an important part of the fire department well past its prime. (Courtesy of City of Benbrook.)

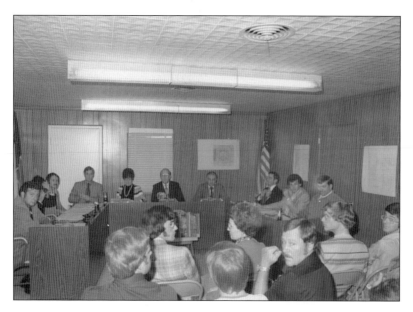

Benbrook City Hall was housed in the same building as the police and fire departments, making for cramped quarters once Benbrook began to grow. This photograph shows a city council meeting in action in the 1970s. (Courtesy of R.E. "Bob" Clark.)

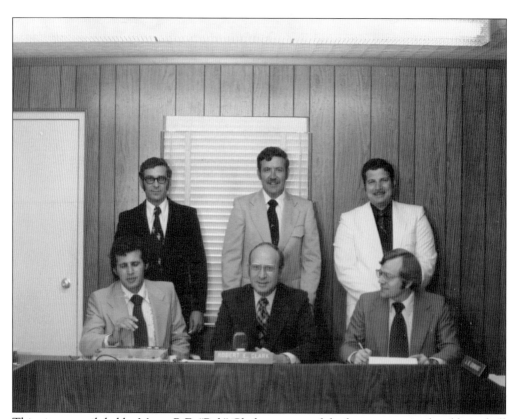

This city council, led by Mayor R.E. "Bob" Clark, was one of the last to meet in the old city hall building located on Del Rio Avenue. The move to the current location on Winscott Road in 1976 was a welcome one for the growing governing body of Benbrook. (Courtesy of City of Benbrook.)

As both Benbrook and Fort Worth grew in population, the Mary's Creek Bridge, originally built in 1922, failed to adequately serve the needs of citizens travelling between towns. As a part of the solution, a unique arrangement had the cities of Benbrook and Fort Worth and Tarrant County all pitch in one-third of the cost to construct a new bridge that could handle the increasing traffic. This photograph shows, from left to right, Benbrook mayor R.E. "Bob" Clark, Tarrant County judge Mike Moncrief, and Fort Worth mayor Clif Overcash at the ground-breaking ceremony. (Courtesy of R.E. "Bob" Clark.)

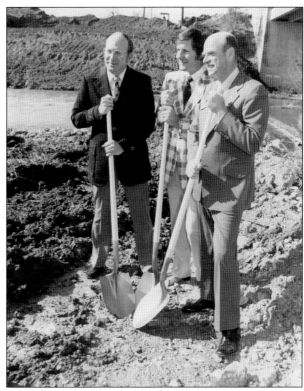

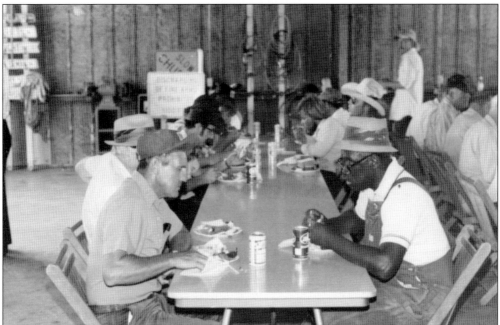

Partnerships play an important role in intergovernmental relations and service to citizens. Benbrook's Public Works Department partners annually with Tarrant County in an asphalt overlay program to provide local street improvements. Each year, the two groups enjoy a barbecue lunch to celebrate the completion of the project. (Courtesy of City of Benbrook.)

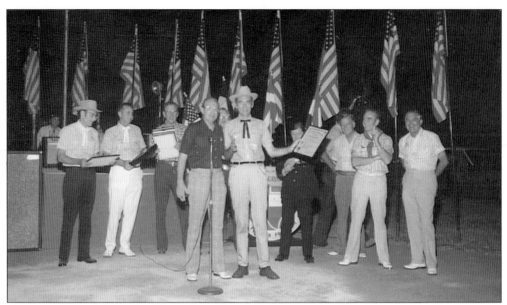

In the 1970s, nearby General Dynamics (GD) was developing the F-16 fighter jet. In order to attract interest and business internationally, the City of Benbrook, along with GD and the City of Fort Worth, hosted a promotion of the F-16 to dignitaries from around the world at the Pate Museum of Transportation. Attending the event were US representative Jim Wright, US senator John Tower, and Benbrook mayor R.E. "Bob" Clark. Wright would later become Speaker of the House. (Courtesy of R.E. "Bob" Clark.)

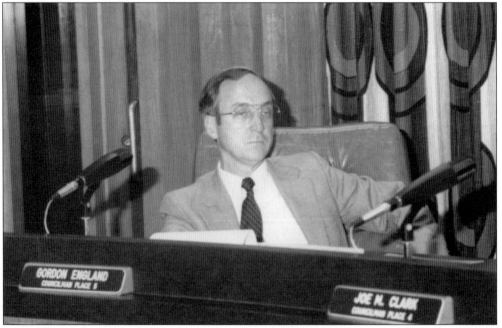

Gordon England served on Benbrook's city council from 1980, when he moved his family to Benbrook to work at General Dynamics, to 1985. England is one of Benbrook's homegrown national figures, as he served as the 72nd and 73rd secretary of the Navy under Pres. George W. Bush and served as the first deputy secretary of Homeland Security. (Courtesy of City of Benbrook.)

Mayor R.E. "Bob" Clark and city secretary Pat Rutherford pose behind a scale model of the new city hall. The building would contain two conference rooms, a circular chamber room for city council meetings, and offices for all city employees. The building, constructed in 1976 and located at 911 Winscott Road, now also houses the Benbrook Economic Development Corporation. (Courtesy of R.E. "Bob" Clark.)

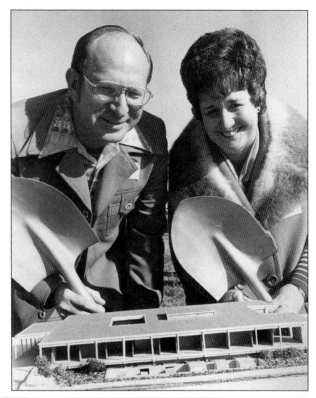

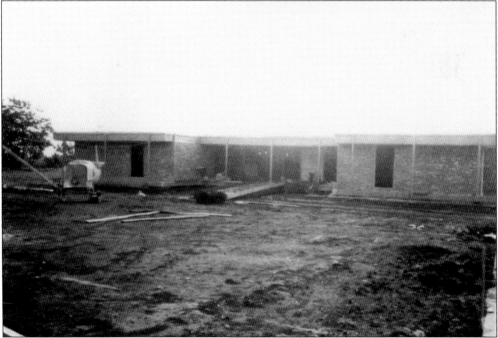

This photograph, taken in February 1976, shows city hall mid-construction. Citizens and city employees enjoyed watching the building as it was being constructed, as it was evidence of the growth and prosperity in their town. (Courtesy of City of Benbrook.)

Although Phil Gramm held many prestigious titles, he was Representative Gramm at the time of this photograph. Serving the Sixth Congressional District, which encompassed cities from Benbrook to College Station, Gramm would appear at Benbrook city council meetings to discuss national as well as local economic and political matters. (Courtesy of City of Benbrook.)

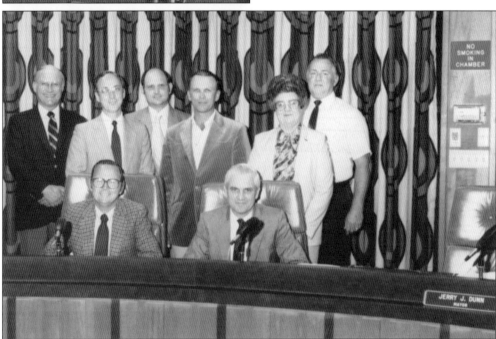

This is a photograph of the 1975 city council with Mayor Jerry Dunn. Dunn was the longest-serving Benbrook mayor. (Courtesy of City of Benbrook.)

Pat Rutherford was the city secretary for Benbrook for nearly 30 years. Benbrook has a history of long-serving and dedicated city secretaries. Mollie Childers, sister of constable Jones Childers, was the first city secretary. The word "secretary" can be misleading. City secretaries are vital to the operation of a city and possess keen knowledge of the inner workings of city government. (Courtesy of City of Benbrook.)

Bill Trammell was a volunteer firefighter who became fire chief in the 1970s. Trammell was an active member of the community. He and his wife, Pat, owned the Benbrook Café, a popular gathering spot for many prominent figures throughout Tarrant County. (Courtesy of City of Benbrook.)

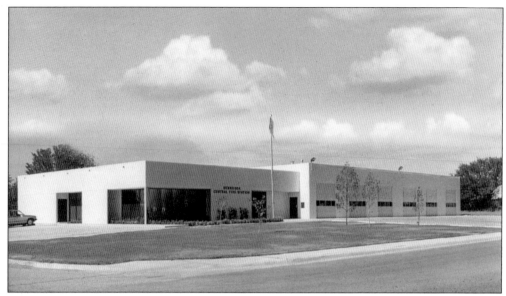

This building, the current Benbrook Fire Department on Mercedes Street, was completed in 1980. At the time, the fire department was still comprised entirely of volunteers. By 1980, the needs of the city had far outgrown the 1950 building. (Courtesy of Benbrook Fire Department.)

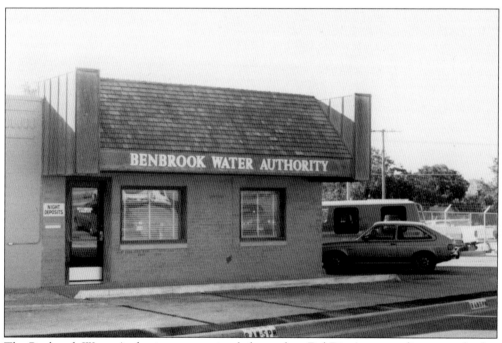

The Benbrook Water Authority was previously located on Del Rio Avenue, adjacent to the fire department, until 1980. Currently, the Benbrook Water Authority facility is located on Mercedes Street, next to the Benbrook Public Library. (Courtesy of Robert Cook.)

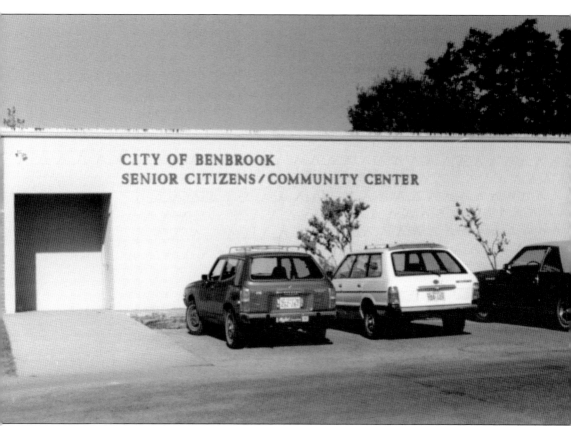

This photograph is of the Benbrook Senior Citizens Center in 1983 at its first location at the corner of Mercedes Street and San Angelo Avenue, commonly referred to as the Lions Club Building. The purpose of the center is to promote the welfare of senior members through planned programs and activities. Today, the Benbrook Senior Citizens Center is located on Mercedes Street, next door to city hall. (Courtesy of Robert Cook.)

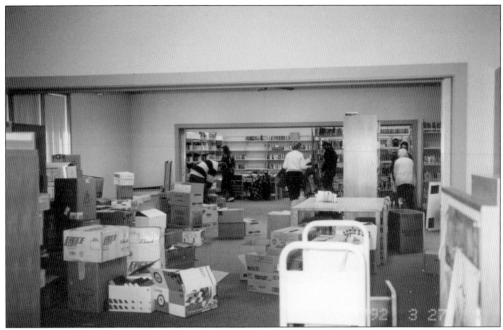

This photograph depicts Benbrook Public Library staff moving into its new location on Mercedes Street, across the street from Benbrook City Hall. The library was previously housed in the old Benbrook Water Authority and city hall offices on Del Rio Avenue. (Courtesy of City of Benbrook.)

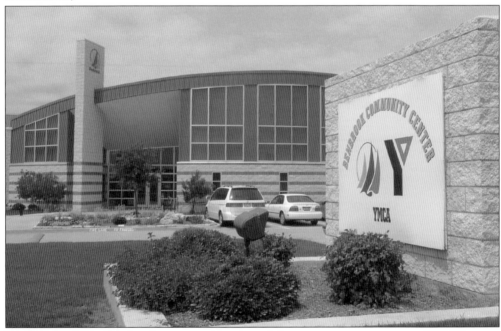

In 2000, the City of Benbrook constructed a state-of-the-art community center at 1899 Winscott Road, complete with basketball courts, walking track, indoor pool, exercise machines, children's play place, rock-climbing wall, and group classrooms. Benbrook partnered with the YMCA of Metropolitan Tarrant County, which manages the facility. (Courtesy of City of Benbrook.)

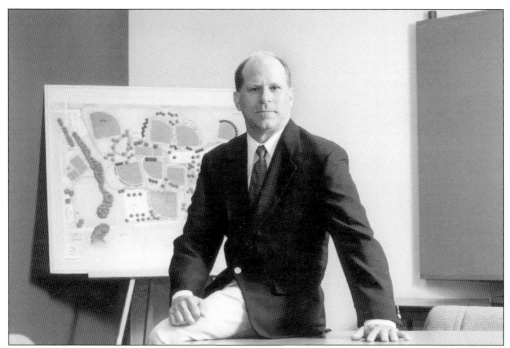

Cary Conklin served Benbrook as the city manager until his retirement in 2007 after 33 years of service, including 10 years as city manager. The city renamed the street leading into Dutch Branch Park "Cary Conklin Drive" in his honor. (Courtesy of City of Benbrook.)

Retiring city manager Ken Neystel stands with future city manager Cary Conklin at Neystel's retirement party. Conklin is dressed as an old farmer, a spoof on Neystel's retirement plans. Neystel served as city manager from 1977 to 1996. Conklin began his Benbrook career in 1974 and served as city manager from 1996 to 2007. (Courtesy of City of Benbrook.)

Benbrook police drive the "new" Mary's Creek Bridge on Vickery Boulevard. The bridge, constructed in 1976, supplemented the original bridge, constructed in 1922. Both bridges were replaced in 1992. (Courtesy of City of Benbrook.)

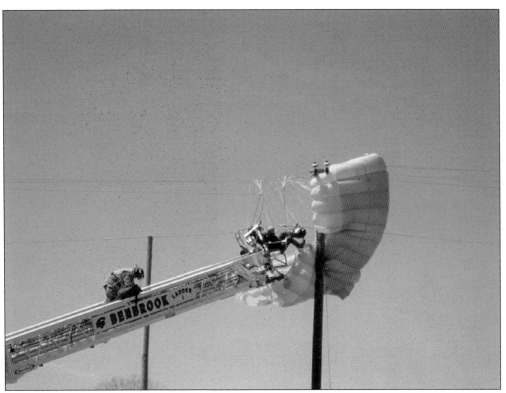

In 2009, an unlucky paraglider ended up tangled in power lines near Benbrook Lake. The Benbrook Fire Department safely removed the paraglider from harm's way. The event attracted many onlookers. (Courtesy of Eugene.)

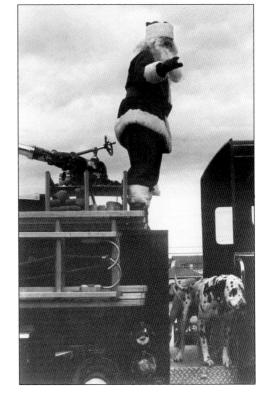

The Benbrook Fire Department has always maintained an active role in the community. In this photograph, a fireman dresses up as Santa Claus, bringing along his reindeer and trusty Dalmatian for the ride around town on one of the city's fire trucks. (Courtesy of Benbrook Fire Department.)

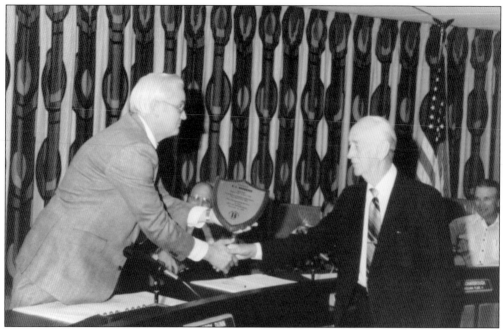

E.L. Magers was a man dedicated to the development of Benbrook. Evidence of this dedication is shown in this photograph, as he is presented with a plaque and certificate for outstanding service by Mayor Jerry Dunn. Magers served as mayor from 1967 to 1969 and as chairman of the planning and zoning commission; he was known for his articulate and knowledgeable style and sincere concern for the well being of the city and its citizens. (Courtesy of City of Benbrook.)

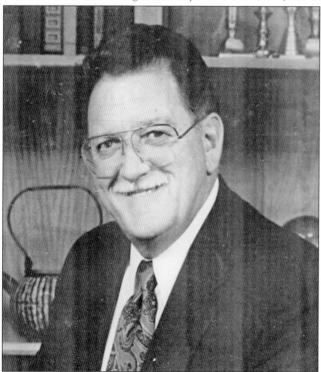

F.T. "Bear" Hebert was Benbrook mayor from 1999 to 2005. Mayor Hebert served three terms and was instrumental in renaming US 377 "Benbrook Boulevard" in Benbrook. (Courtesy of City of Benbrook.)

Pictured are police chief Bob Richardson (center) and Benbrook Water Authority (BWA) employees Zollie Allen (left) and Carroll Crombie (right). Richardson served as Benbrook's police chief from 1981 to 1993. Crombie served as BWA general manager from 1979 to 1993. Allen was a BWA employee from 1970 to 2001 and general manager from 1996 to 2001. (Courtesy of City of Benbrook.)

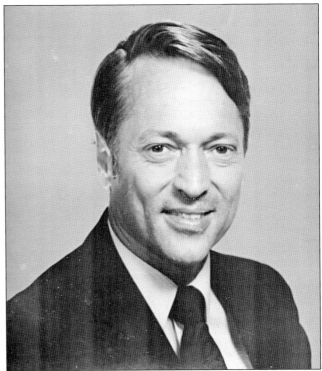

L.E. Heizer was mayor of Benbrook from 1961 to 1966. (Courtesy of City of Benbrook.)

City manager Ken Neystel (left) and city council member and future mayor Dr. Jerry Dittrich pose for a photograph at Neystel's retirement party. (Courtesy of City of Benbrook.)

Wayne Wilson was mayor of Benbrook from 1970 to 1974. (Courtesy of City of Benbrook.)

Five

BENBROOK LAKE AND DAM

Benbrook history is riddled with stories of disastrous flooding. Although a reliable water source, such as the Trinity River and its various tributaries, was vital to the earliest settlers of the area, it also posed great risk. Major floods in the first half of the 20th century threatened not only homes and ranches but also the growing downtown area of Fort Worth.

Finally, in 1947, as a part of the Rivers and Harbors Act of 1945, the US Army Corps of Engineers was authorized to build a lake and dam that would mitigate the potential of flooding in the area.

The location selected to construct the lake and dam was the site of many of the first homes in Benbrook, including Dutch Branch Ranch, the home of Elliott Roosevelt, son of Pres. Franklin Delano Roosevelt and Eleanor Roosevelt. The US Army Corps of Engineers took great care to preserve any artifacts found in the area and relocated several family cemeteries to their current location in Benbrook Cemetery, located at Mercedes Street and Winscott Road.

Since the construction of Benbrook Lake, major floods have been avoided. The lake also provides water to much of the North Texas region. Although later chapters show how the lake developed as a central recreational destination for the region, this chapter illustrates the development and construction of Benbrook Lake.

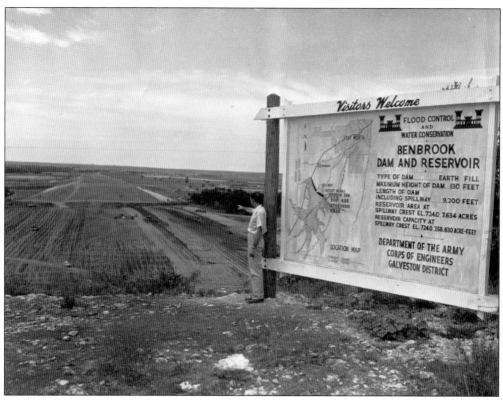

A sign was erected in 1947 to show the location of the new lake and dam funded by the Rivers and Harbors Act of 1945. The US Army Corps of Engineers undertook the project to control flooding in the area and provide a local water source to Benbrook and surrounding communities. (Courtesy of US Army Corps of Engineers.)

The Benbrook Water Authority provides Benbrook's water and sewer service. The City of Benbrook was incorporated in 1947, when the community of approximately 50 people was served by individual water wells and septic tanks. In 1949, the city granted a franchise to the Worth Water Company to install and operate a water system in Benbrook. In 1955, the Benbrook Water Authority was established by the Texas Legislature as a water conservation and reclamation district and assumed the assets of the Worth Water Company. (Courtesy of Robert Cook.)

This photograph shows the area that would become Benbrook Lake prior to construction. The construction of the lake required the relocation of several family cemeteries, utility lines, roads, and bridges and the rerouting of six miles of the Gulf, Colorado, and Santa Fe Railways. (Courtesy of US Army Corps of Engineers.)

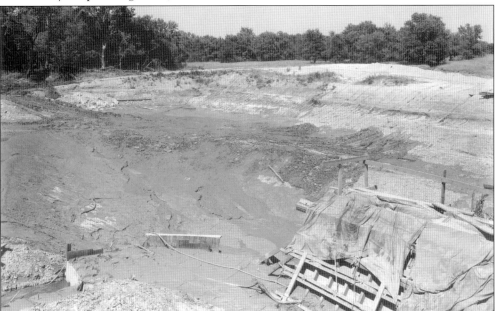

In May 1949, construction of the dam was temporarily halted due to flooding. The floods took 11 lives. This photograph shows silt buildup in the outlet channel as a result of a flood on June 2, 1949. Major flooding had also occurred in 1908, 1922, and 1936. The area's susceptibility to flooding was the primary reason the Clear Fork of the Trinity River was impounded. (Courtesy of US Army Corps of Engineers.)

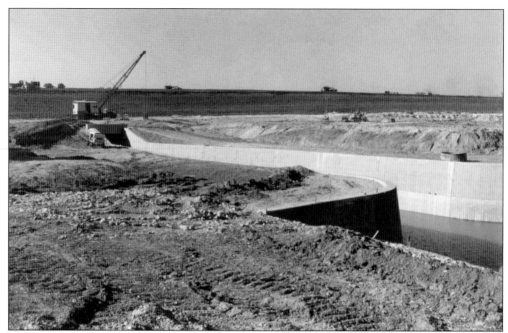

Benbrook Lake was originally designed as a vital link in a statewide project to connect the Gulf Coast to the Dallas/Fort Worth area through a channel/canal system. Although the system never came to fruition, the dam and lake were part of a series of lakes designed and constructed to support the transport of goods via channel/canal. (Courtesy of US Army Corps of Engineers.)

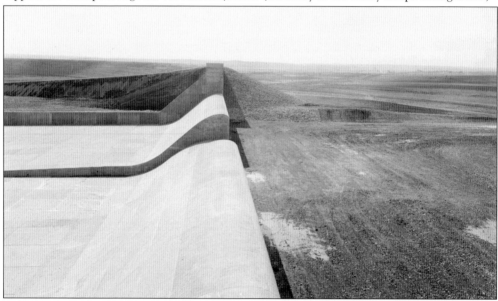

Taken on February 20, 1951, this photograph shows the completed uncontrolled spillway and channel. The elevation of the spillway is 710 feet, a lake level the Corps of Engineers anticipated would be reached every 40 years. Water first flowed over the uncontrolled spillway in May 1957. Similarly, design engineers estimated that the lake level would rise above 715 feet once every 100 years. This lake level has been exceeded three times since impoundment of the lake: in 1989, 1990, and 1991. (Courtesy of US Army Corps of Engineers.)

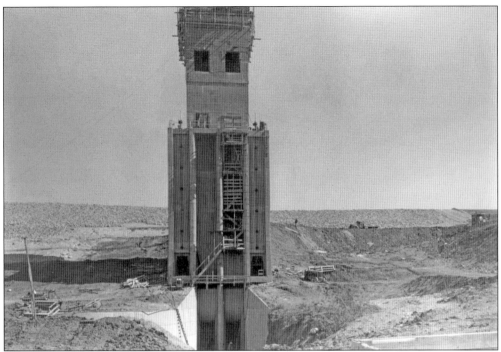

This photograph shows the interior of the incomplete control tower. The control tower monitors the water level and controls the flood gates by using electric cables that run through the tower. While the dam also included a spillway for uncontrolled flood management, operations from the control tower are invaluable to the maintenance of the lake and dam. The photograph below shows the completed control tower, which is accessed by a bridge connecting to the rip-rap embankment. (Both, courtesy of US Army Corps of Engineers.)

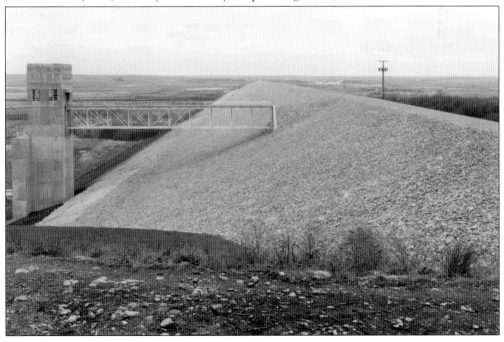

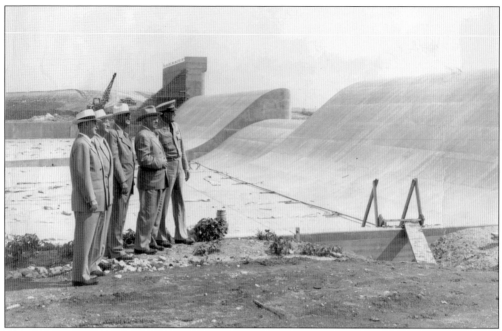

The first flood after the construction of the lake and dam occurred in May 1957. The lake and dam prevented over $9.3 million in property damage during the flood event, nearly recouping the $14.5-million price tag for construction of Benbrook Lake. (Courtesy of US Army Corps of Engineers.)

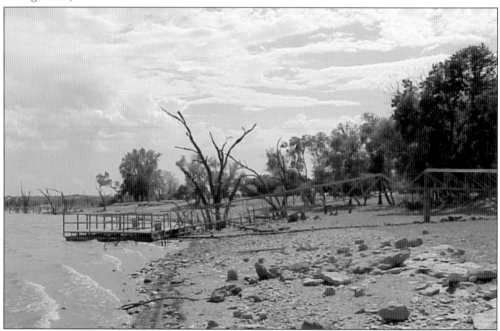

Although the Benbrook area has been known for its susceptibility to flooding, Benbrook has also been affected by drought. This photograph, taken in 1999 at the Holiday Park fishing pier, shows the floating pier nearly sitting on the bottom of the lake. (Courtesy of US Army Corps of Engineers.)

Six

BENBROOK BOULEVARD

The present-day configuration of Benbrook has been greatly influenced by the automobile. The first mechanized transportation to reach the area was the Texas and Pacific Railroad in 1880, along the present route of the Union Pacific Railroad. Some roadways predate the incorporated city. These roads include Old Benbrook Road, Aledo Road, Benbrook Boulevard/US 377, Winscott Road, Mercedes Street, Sproles Drive, Chapin Road, Vickery Boulevard, and RM 2871. Subsequent development has been oriented around and along these original roadways.

The original settlement of Benbrook was located within a four-block area around the railroad station, near the present juncture of Interstate 20 and Benbrook Boulevard/US 377 along Aledo Road.

The natural pathways to and from needed goods and services developed over time and resulted in the city's major thoroughfare, Benbrook Boulevard/US 377. As can be predicted, small businesses opened up along the roadway to serve the needs of community members and travelers. Today, Benbrook Boulevard/US 377 serves as the community's central business corridor.

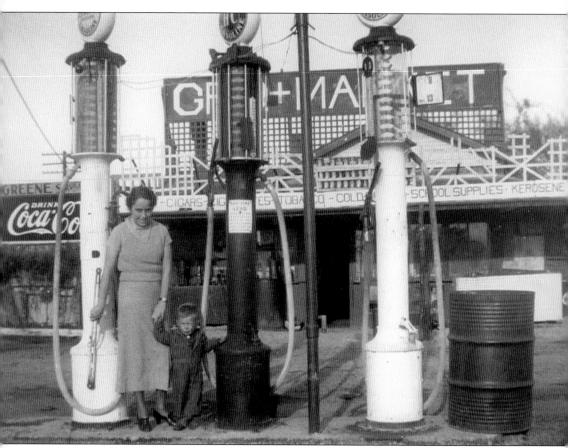

This store, owned by Frances and Marvin Greene from 1931 to 1938, was known as The Stand. The Greenes sold canned goods and other staples and operated a fresh meat counter. The Stand was a two-room store, also providing living quarters for the owners, which included a bedroom, kitchen, outhouse, and well. (Courtesy of Carol Pearcy Shour.)

M.N. "Dick" Wallace served as Benbrook's mail carrier. Pictured in 1957, Wallace was a well-known figure in town, beginning his mail carrier career in the 1920s. Dick Wallace was also one of the only mail carriers who delivered mail to rural residences by car. During the Great Depression, Dick Wallace would leave groceries at the mailboxes of rural homes to help ease the burden of those most in need. (Courtesy of Mary Wallace Layne.)

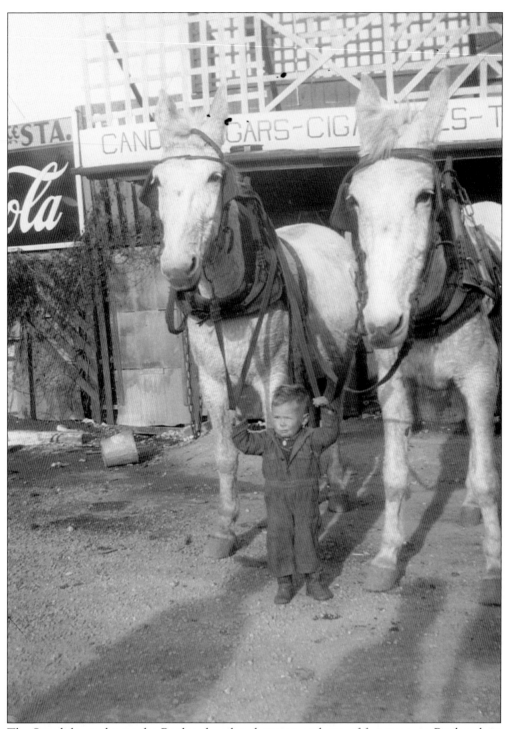

The Stand, located near the Benbrook railroad station and one of few stores in Benbrook in the 1930s, was a favorite for travelers stopping to water their horses in nearby Mary's Creek. Pat Greene, son of store owners Frances and Marvin Greene, kept an eye on the horses. (Courtesy of Carol Pearcy Shour.)

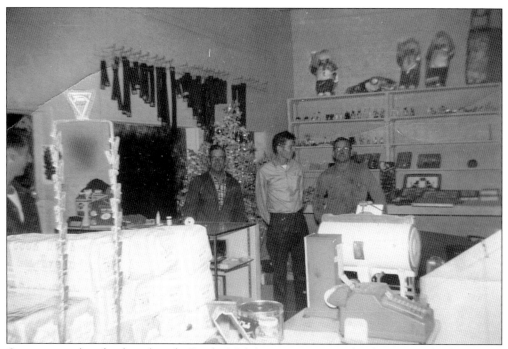

Carrying a multitude of supplies, the Bowles Mobil station was a social gathering spot for the citizens of Benbrook. The station carried canned goods and other groceries as well as car repair items. A mechanic shop was located just behind the station. (Courtesy of Joanne Bowles Eason.)

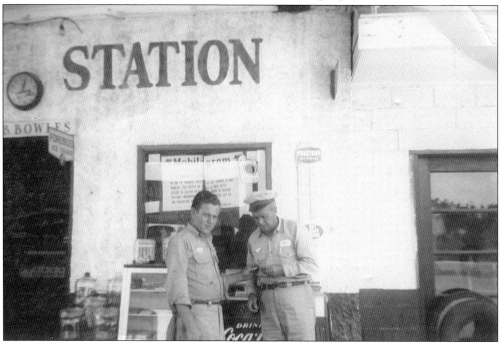

J.B. Bowles, shown here with an attendant, was the owner of this Mobil service station. This was the only service station in the area when the city was incorporated in 1947. Bowles ran the station until his death in 1987. (Courtesy of Joanne Bowles Eason.)

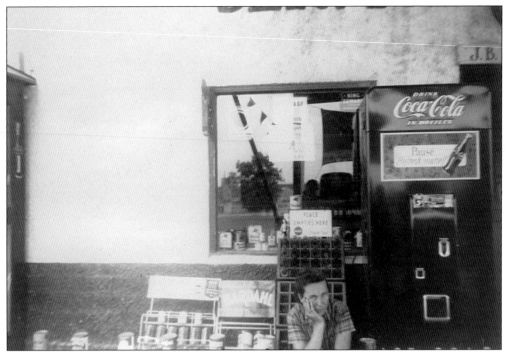

Opal Bowles, the wife of J.B. Bowles, was as much a staple at the Mobil station as her husband. The station was open from 6:00 a.m. to 9:00 p.m., and J.B. and Opal were the only employees for the first years of the station's operation. While their parents worked at the station, the Bowles children were closely looked after by nearby neighbors. (Courtesy of Joanne Bowles Eason.)

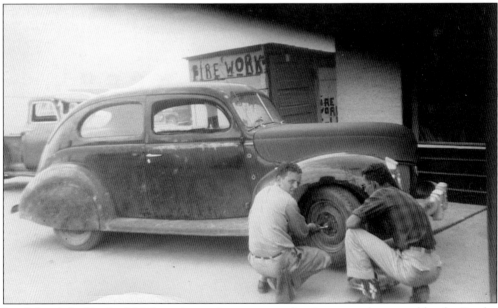

Just behind the Bowles Mobil service station was a mechanic garage also owned by the Bowles family. This photograph shows local mechanics changing the tire of a car, the vehicle's owner no doubt traveling through town. A fireworks stand can also be seen in the background of this 1940s photograph. (Courtesy of Joanne Bowles Eason.)

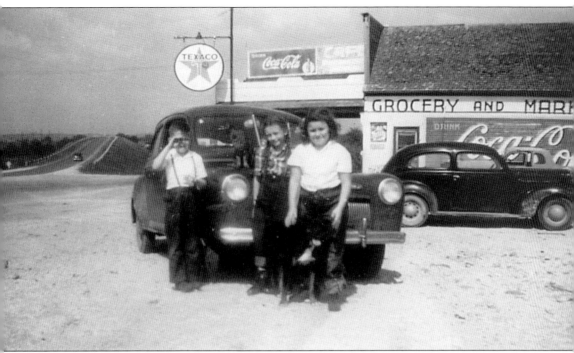

Taken in the early 1940s, this is a photograph of, from left to right, Alex and Mary Wallace, along with Pat Moore. The Wallaces sold the store to the Moore family in 1938, and their children often played together outside the store. (Courtesy of Mary Wallace Layne.)

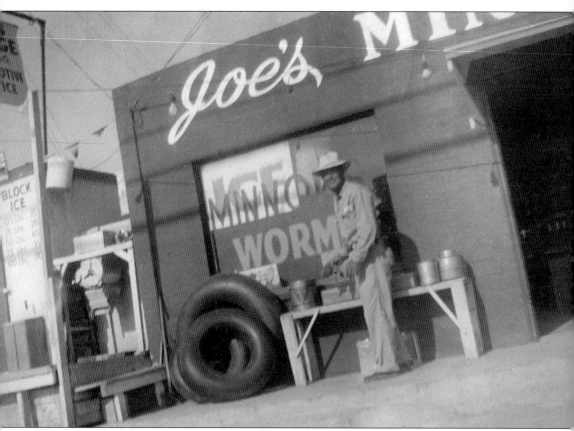

Joe's Minnow, owned by Joe Bowles, was one of the first bait shops on US 377. The impoundment of Benbrook Lake brought many fishermen to the area, and the minnow business was quite prosperous. Joe's granddaughter, Joanne, helped him at the shop and thought she had struck it rich when he paid her a salary of $20 a week. (Courtesy of Joanne Bowles Eason.)

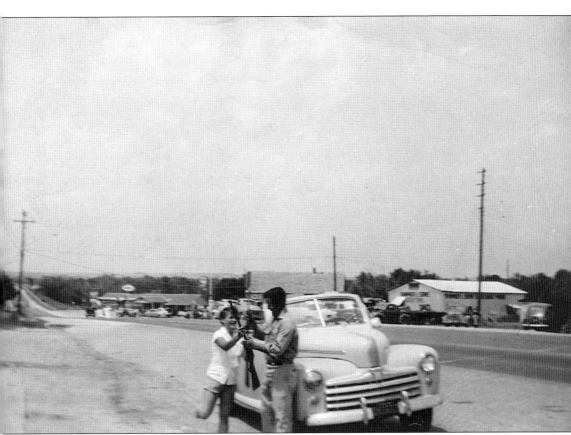

This photograph shows Joanne Bowles Eason and Hughie Biggs along US 377 preparing for a hunting trip. In the background are several businesses that were located on US 377, including the post office and Skinner's Wrecking Yard. (Courtesy of Joanne Bowles Eason.)

Childers Grocery Market and Gas Station included a service station, a repair shop, an ice house, and a meat market. Owners Jim and Frieda Childers often had help from Jim's younger brother, Bill, who is shown in this photograph wearing wading boots and standing next to Frieda. (Courtesy of Cindy Childers Hughes.)

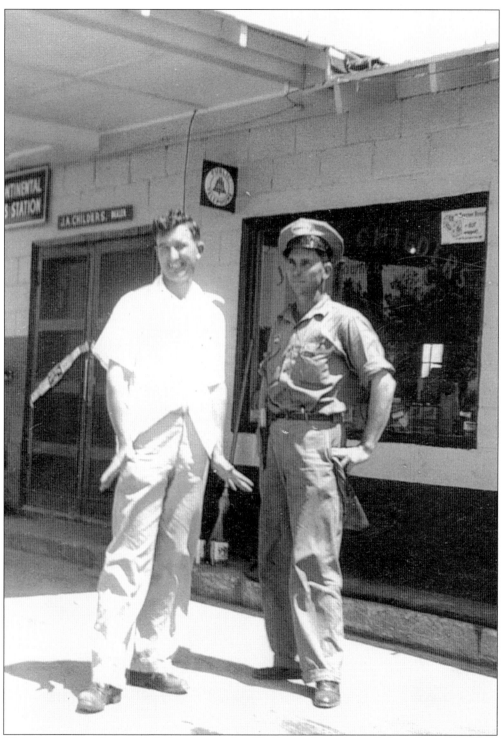

This photograph, taken in 1949, shows owner Jim Childers with employee Aubrey Slaton. Motorists would often stop at the shop to have their vehicles serviced by Slaton. In the background, a sign identifies the shop as the town's bus station. (Courtesy of Cindy Childers Hughes.)

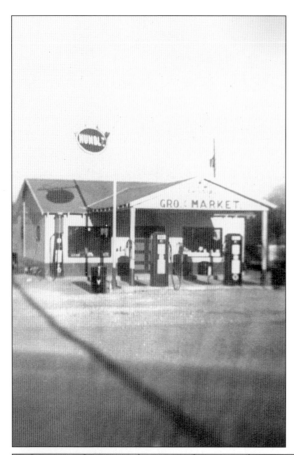

Childers Grocery Market and Gas Station opened its doors on December 10, 1946, on US 377 at the corner of Old Benbrook Road. The picture of the interior of the store, taken in 1948, shows Jim Childers, obviously proud of his venture, with Joe Reiser, the market's delivery man. Aubrey Slaton, a service man, can be seen sneaking in the door. (Both, courtesy of Cindy Childers Hughes.)

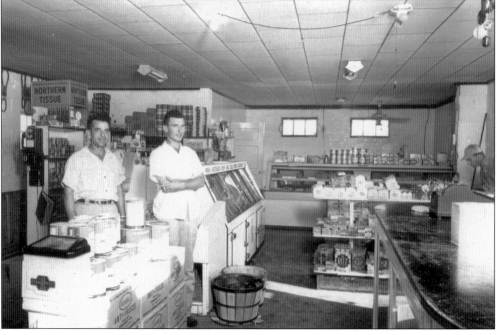

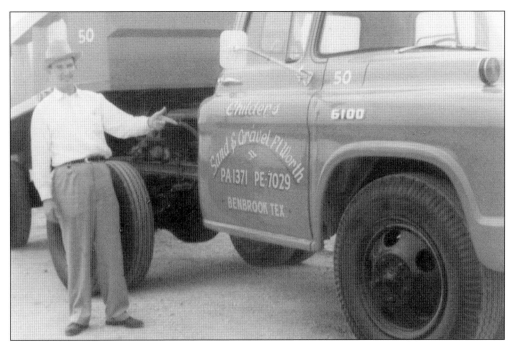

Jim Childers was a born entrepreneur. In addition to owning the grocery and filling station, Childers opened Childers Sand and Gravel Company. (Courtesy of Cindy Childers Hughes.)

The office building pictured here was the headquarters of the gravel company, located at the corner of Mercedes Street and Winscott Road, where city hall currently stands. Commissioned by the US Army Corps of Engineers, Childers's company won the bid to build a road around Benbrook Lake. (Courtesy of Cindy Childers Hughes.)

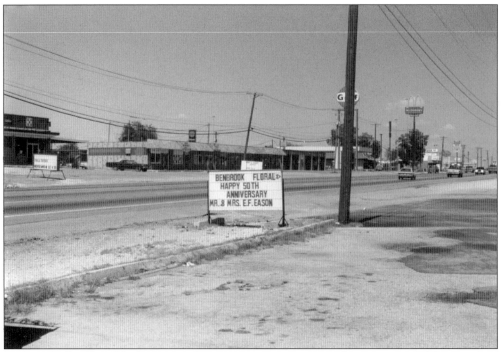

Benbrook Floral would often use its business sign to announce local events and happenings. Business development along US 377 in Benbrook, including the McDonald's and Whataburger, can be seen in the background. (Courtesy of Joanne Bowles Eason.)

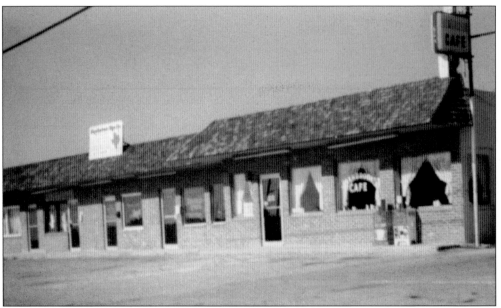

Benbrook Café, owned by Bill and Pat Trammell, was a local meeting place for Benbrook and greater Tarrant County. The Benbrook Café closed in the mid-1980s, but many Benbrook citizens have fond memories of the establishment. (Courtesy of Jack Johnson.)

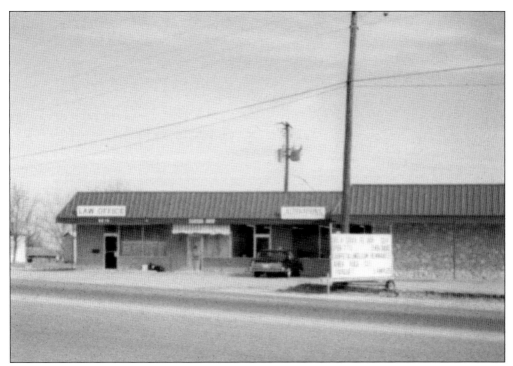

This photograph, taken in 1979, shows one of the first major commercial developments in the city. The development housed a law office, dog grooming business, hair salon, and alterations establishment. (Courtesy of Jack Johnson.)

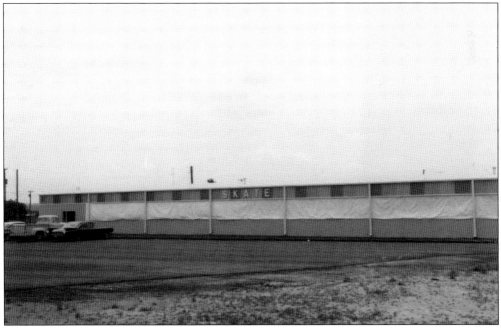

Benbrook's own skating rink, built in 1963—the year this photograph was taken—was located on Mercedes Street. Today, the location is home to several businesses as a part of the Mercedes Plaza complex. (Courtesy of Jack Johnson.)

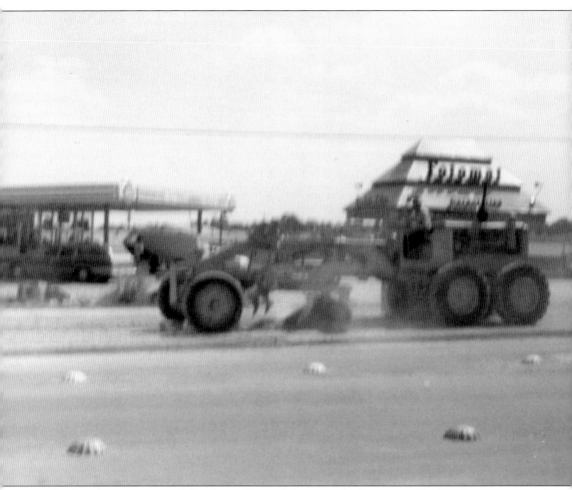

Benbrook proprietor and developer Duane Johnson, who has many Benbrook streets named both after him and by him, operates a motor grader in front of buildings he leased on Benbrook Boulevard/US 377. Neither the Dairy Queen nor the Fotomat remains; the site is now home to a Burger King on the corner of Benbrook Boulevard/US 377 and Mercedes Street. (Courtesy of Jack Johnson.)

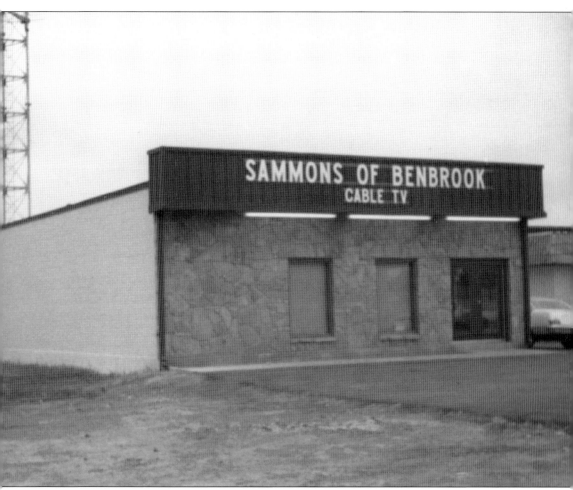

This is a 1979 photograph of the Sammons Cable TV office in Benbrook. At the time, cable companies were required to maintain a storefront in the towns where they provided cable service. The building was occupied by Sammons Cable for over 15 years. Today, it is the location of the Benbrook Pharmacy, located on Mercedes Street. (Courtesy of Jack Johnson.)

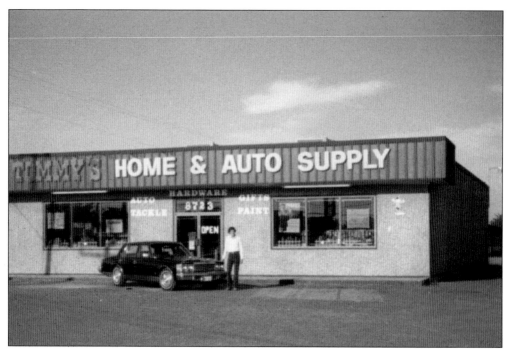

Tommy's Home and Auto Supply was a Benbrook staple in the 1970s and 1980s. Also owned by the Johnson family, Tommy's was closed in the late 1980s. The building still stands and is currently occupied by Domino's Pizza. (Courtesy of Jack Johnson.)

This photograph shows how much Benbrook had grown by 1983, with bustling cars and many new businesses popping up. The Risky's Barbecue restaurant shown in the photograph is still in operation today. This intersection of Sproles Drive and Benbrook Boulevard/US 377 looks much different today as the city continues to attract new businesses to the area. (Courtesy of Robert Cook.)

Seven

SERVICE AND RECREATION

Benbrook places community service high on its list of priorities. From the earliest settlers who undoubtedly helped ill neighbors to mail carrier Dick Wallace assisting hungry families during the Great Depression to the volunteers who made up the first fire department, Benbrook residents have always pitched in to make a difference. With today's active civic and nonprofit organizations and the commitment of many dedicated volunteer groups, the success of Benbrook is still measured by the commitment of its residents.

When Benbrook was first settled, families that moved here were looking for a new start. With huge tracts of land that had to be constantly worked in order to produce yields for profit and the labor that farming required, there was not much time for play. As Benbrook flourished and families found more time for leisurely pursuits, emphasis was placed on outdoor activities. Over time, the city took advantage of the vast park land surrounding Benbrook by adding bike trails that connect to other trails throughout Tarrant County, tennis courts, basketball courts, sand volleyball courts, baseball fields, soccer fields, duck ponds, picnic pavilions, walking trails, pedestrian bridges, and playgrounds. Benbrook also enjoys a golf course, youth sports opportunities, and horse riding facilities. The US Army Corps of Engineers maintains Benbrook Lake, where residents have long enjoyed picnicking on the shores, fishing, sailing, motor boating, and various other water sports.

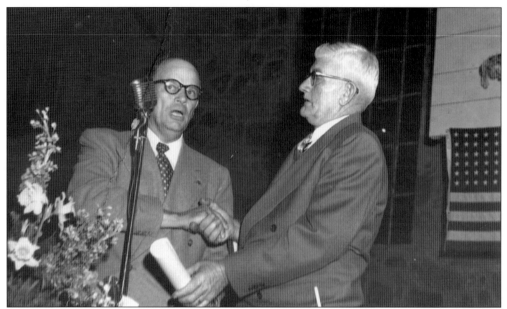

The Lions Club has played an important role in community service since its installation in 1953. The installation ceremony was a community-wide event held in the Benbrook School gymnasium. The first president of the Lions Club was Mayor A.R. "Pop" Cartwright, right, pictured with the president of the White Settlement Lions Club, who performed the ceremony. (Courtesy of Cindy Childers Hughes.)

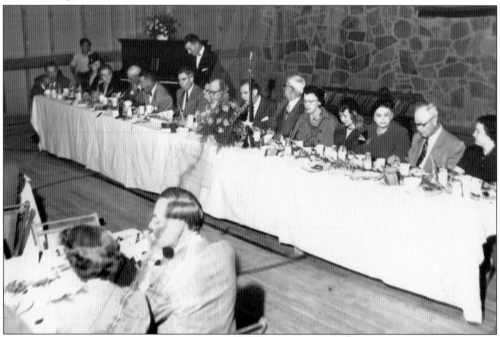

The reception dinner held after the installation, which was attended by most of the community, included former mayor Ed Sproles and wife, Mable, current mayor A.R. "Pop" Cartwright and wife, Alberta, and Jim Childers (standing). Cartwright was mayor from 1952 to 1961. (Courtesy of Cindy Childers Hughes.)

Lions Club meetings were large events for Benbrook citizens where a full meal was served and many items of importance were discussed. The Lions Club is a service-based organization created in 1917 to serve communities in which it is located. The Benbrook chapter was created in 1953 and is still active today. While meetings were originally held at Benbrook Elementary School (here), the Lions Club eventually built its own building on the corner of Mercedes Street and San Angelo Avenue. (Courtesy of Cindy Childers Hughes.)

Jim Childers was active in many organizations throughout his life, including the Lions Club, local government, and the Freemasons. A social fraternity within the Freemasons known as the Shriners frequently appeared in parades and other events wearing the traditional fezzes and riding motorcycles. (Courtesy of Cartwright family.)

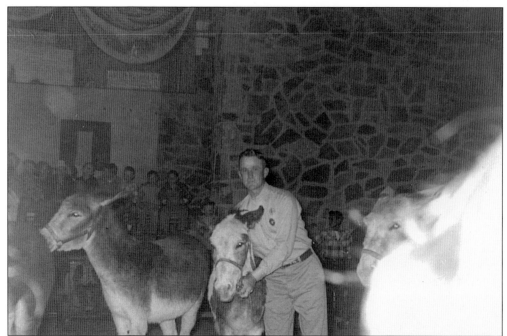

When the fire department was first created in 1950, it was an all-volunteer squad. The volunteers were left footing the bill not only their own supplies but also for supplies and equipment for the station. One of the best-received fundraisers was the "Donkey Basketball" game held annually in the school gymnasium. Aubrey Cartwright, owner of Cartwright Stables, supplied the donkeys, and many prominent citizens, including fire chief Jim Childers (standing) and Joe Skinner of Skinner's Wrecking Yard (riding) participated. Children loved to watch from the bleachers. (Both, courtesy of Cindy Childers Hughes.)

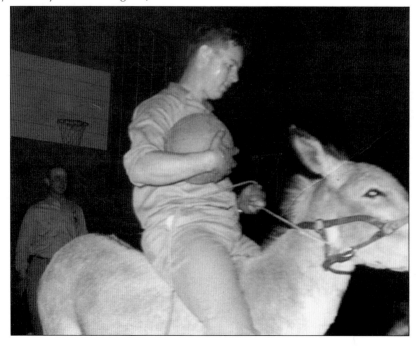

Cutting horse trainer Matlock Rose was one of the most highly regarded trainers not just in Texas but in the entire country. He worked horses all over the state, including Dallas and Houston. Matlock and wife Freddie frequently stopped at the Childers Grocery Market and Gas Station when they were travelling across the country training and showing their horses. (Courtesy of Cindy Childers Hughes.)

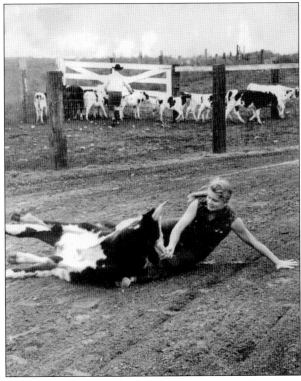

On the weekends, friends of the Cartwright family would head out to the Cartwright Ranch for a day of sport and fellowship. There were plenty of cattle on the ranch, which was also a dairy. This is a photograph of Carolyn Cartwright showing off her shootdoggin' skills during one of their weekend get-togethers. (Courtesy of Cartwright family.)

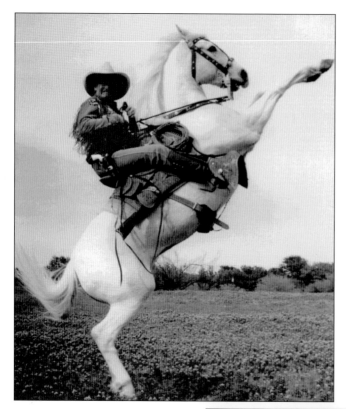

The Cartwright family has been a North Texas staple in the western world for over three generations. This photograph shows Alan Cartwright posing for an advertisement in a lush field of Texas bluebonnets for the family's Wild West show at the Fort Worth Stockyards in 2000. (Courtesy of Cartwright family.)

This photograph was taken in 1979 on the Cartwright Ranch in Benbrook, Texas. Alan Cartwright landed a job as Clint Eastwood's stunt double in the movie *Bronco Billy*. Cartwright also acted as technical advisor on the set. Cartwright Ranch horses appeared in the film, which premiered in 1980. (Courtesy of Cartwright family.)

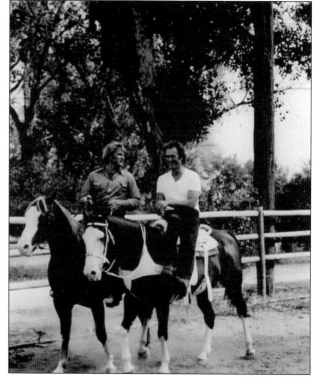

The Miss Flame Pageant was an annual fundraiser hosted by the all-volunteer Benbrook Fire Department. This 1969 photograph shows, from left to right, police chief Johnny Prince, top winners Sondra Curtis, Glenda Simmons, and Linda Carmichael, and fire chief Bill Trammell. (Courtesy of Linda Carmichael.)

Miss Texas from the Miss America pageant rode in the Benbrook Celebration Parade atop her official Miss Texas car. The parade kicked off the weekend-long celebration of the city's incorporation. The parade route began at the old city hall and travelled the length of US 377 to the city's stable and arena. (Courtesy of Cartwright family.)

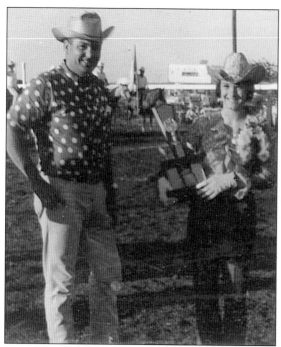

Police chief Johnny Prince and champion rider Linda Carmichael pose outside the Benbrook Saddle Club Arena. The arena was located beside the duck pond at Dutch Branch Park. Saddle clubs from all over the state practiced and competed in several competitions, including barrels, poles, flags, keyholes, and relays. (Courtesy of Linda Carmichael.)

Being involved in Western shows means that actors have many tricks in their holster. Alan Cartwright practices his whip cracking skills with his mother, Carolyn Cartwright, on their ranch in Benbrook. The Cartwrights have entertained at western shows all over the nation, including the Fort Worth Stockyards and Six Flags Over Texas in Arlington. (Courtesy of Cartwright family.)

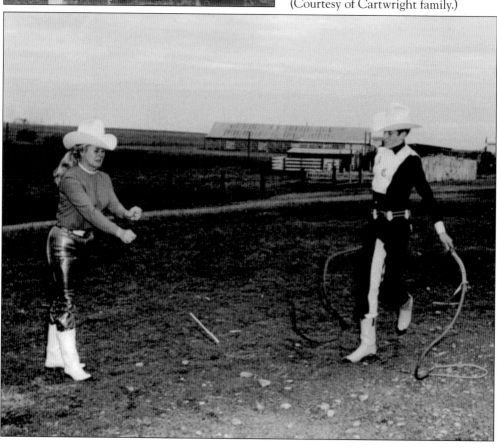

The families involved in the Benbrook Saddle Club frequently held playdays for children and adults to practice riding horses. In an effort to keep up with club costs, Carolyn Cartwright, Donna Wilson, and Alice Carmichael (from left to right) sold concessions to the families who would spend entire days at the stables with the saddle club. (Courtesy of Linda Carmichael.)

This photograph shows, from left to right, NaRay Hood, Carolyn Cartwright, and Elizabeth Markum sitting atop the fence of the arena at the Benbrook Horseshoe Club. Opened in 1953, the same year this picture was taken, the Benbrook Horseshoe Club was a place where riders could practice and compete. This was the same time that Carolyn Cartwright began her barrel racing career. (Courtesy of the Cartwright family.)

Linda Carmichael, shown here, built her life in Benbrook around her horses. In 1968, she represented the Benbrook Saddle Club as the Saddle Club Queen and served as Miss Texas for the American Paint Horse Association. (Courtesy of Linda Carmichael.)

Parades in Benbrook usually included the Cartwright family leading the parade with the American and Texas flags. This photograph was taken as the parade continued down US 377 past Boat City Marine, located where the CVS pharmacy is today. Cars lined the entirety of the street to watch the parade. (Courtesy of the Cartwright family.)

The saddle club held an annual banquet to present awards to the riders in each age group. This photograph from 1968 shows the top winners of that year, from left to right: (first row) Cindy Prince, Mary Carmichael, Babs Miller, and Dorothy Miller; (second row) Bing Carmichael, Jack Weaver, Johnny Price, and Herbie Miller. (Courtesy of Linda Carmichael.)

Benbrook resident Carolyn Cartwright poses with a Dan Coates Sr. Appaloosa stud horse at the inaugural Cleburne Rodeo in 1953. Carolyn was just beginning her career as a professional barrel racer and was frequently crowned Rodeo Queen wherever she competed. (Courtesy of Cartwright family.)

This photograph shows young Bing Carmichael at the Fort Worth Stockshow Parade in the 1960s. The Carmichaels were one of several families representing the Benbrook Saddle Club in the parade. His sister, Linda Carmichael, remembers that the weather was a freezing 16 degrees, but saddle club members refused to wear coats while posting the club's colors of red and white. (Courtesy of Linda Carmichael.)

This car wash, located on US 377 and owned by Jack Johnson, was a popular hangout for the kids in the Benbrook Saddle Club, since a car wash was the perfect place to wash their horses. After getting their horses clean, they would take them across the street and tie them up while they grabbed a bite to eat at the local Dairy Queen. (Courtesy of Jack Johnson.)

The parade of the annual Benbrook Celebration led to the stable arena, where a western show was put on for spectators every September. Driven by veterinarian H. Gill, this carriage belonged to the Cartwright family and led the parade to the horse arena every year. The parade was a big production for the city and the only time during the year when US 377 was shut down. (Courtesy of Cartwright family.)

Benbrook celebrated its 24th anniversary in a big way. At the annual Benbrook Celebration, Miss Texas 1971, Janice Blain, took part in the festivities and posed in this photograph with Mayor Wayne Wilson, Carla Turner, and two unidentified but starstruck young girls. (Courtesy of Cartwright family.)

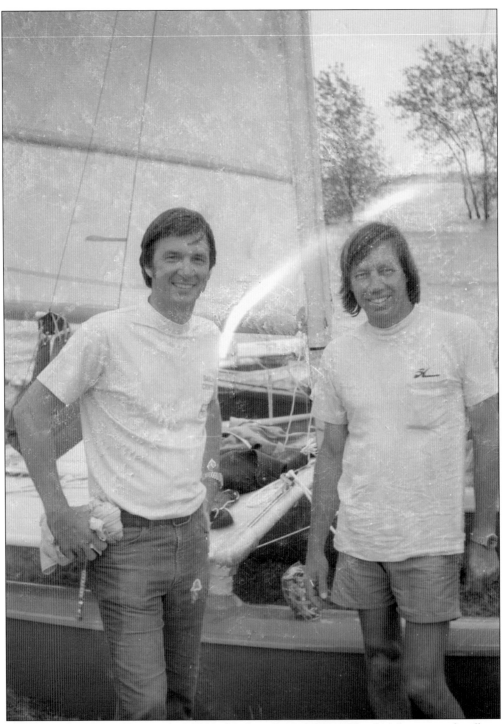

This photograph was taken in the 1970s of Sailing Center owner Chuck Atkinson and sailboat designer Hobie Alter of Hobie catamarans. The two worked closely together to create beautiful boats and teach people the art of sailing. People came from all over to learn from them. (Courtesy of Chuck Atkinson.)

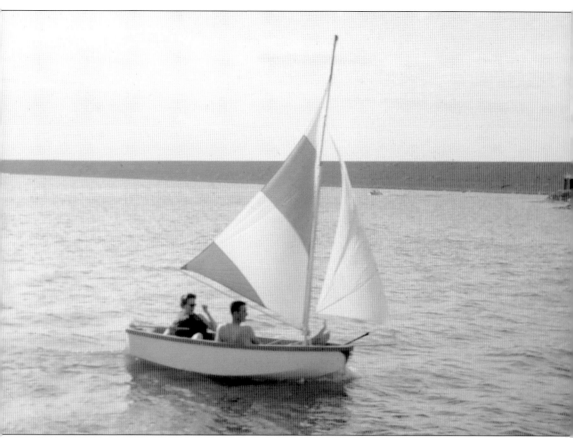

Chuck Atkinson began his sailing career after he left the Air Force. While an engineer at what is today Lockheed Martin, he began sailing, earning the title of state champion in 1963. This photograph shows Atkinson with his cousin in his first sailboat, a modest Hummingbird from Sears. (Courtesy of Chuck Atkinson.)

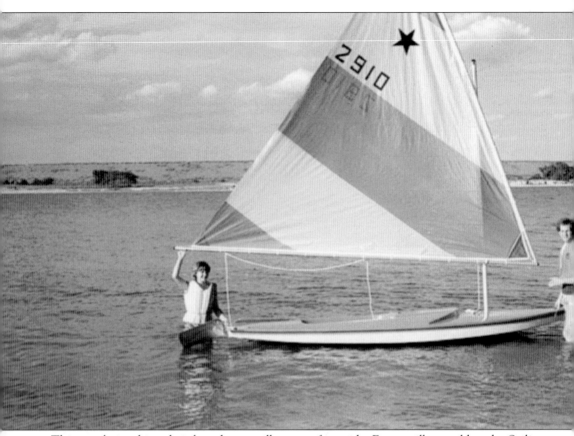

This couple is taking their brand new sailboat out for a ride. Every sailboat sold at the Sailing Center came with a complementary sailing lesson. Chuck Atkinson, owner of the Sailing Center, was well known for never letting a sailor on the water without a life jacket, and these two are no exception. (Courtesy of Chuck Atkinson.)

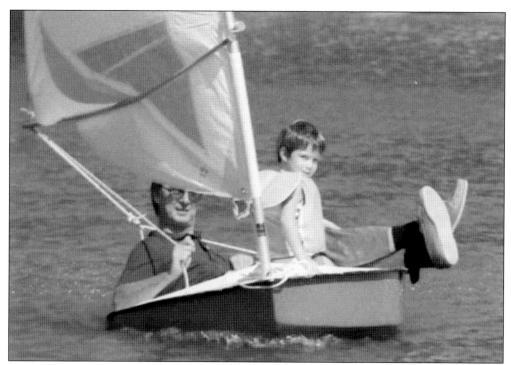

Since Benbrook Lake was completed in 1952, people have come from all over the North Texas area to enjoy recreational opportunities provided by the lake. (Courtesy of Chuck Atkinson.)

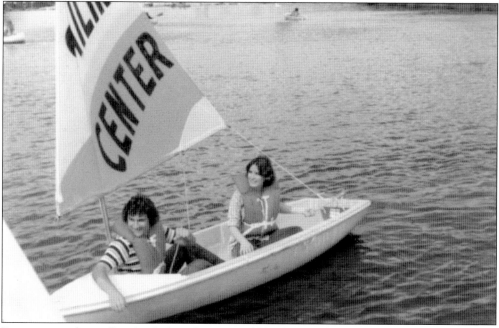

Every spring, the staff at the Sailing Center would load up small sailboats and take them to Fort Worth's Mayfest spring festival, along the Trinity River, to advertise the center and the sport of sailing. Anyone interested in sailing could rent the boats to sail the Trinity River. (Courtesy of Chuck Atkinson.)

New Design Sailboats, located within the same building as the Sailing Center, built sailboats. This sailboat show was the first show in the present-day Fort Worth Convention Center. With New Design building boats and the Sailing Center selling them, the sailing industry in Benbrook took off in the 1970s. (Courtesy of Chuck Atkinson.)

Benbrook Lake offered the city an opportunity to promote tourism. This postcard from the Lake Benbrook Resort and Marina boasts a hotel, located on the lake, that included an Olympic-sized swimming pool, 42 rooms, a restaurant, and a convention center. The resort was advertised as a place to relax and take advantage of water sports and recreation. (Courtesy of City of Benbrook.)

In 1980, Aubrey Atkinson and Harvey Mueller look out over Benbrook Lake towards the northeast and Benbrook Dam from the outdoor deck of the Atkinson home. Though the deck is still used frequently, the view seen from it is now wooded due to the growing foliage in the area. (Courtesy of Chuck Atkinson.)

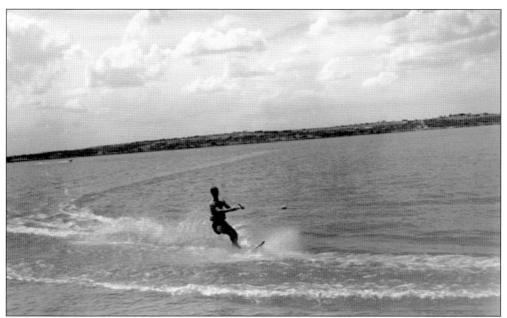

Water sports have been a popular activity on Benbrook Lake for many years. (Courtesy of Chuck Atkinson.)

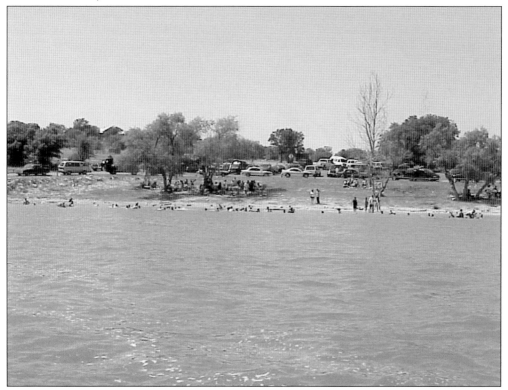

During the 1970s, there could be up to 100 sailboats in the water on any given weekend. This photograph shows how crowded the lake shores could get too, with people trying to beat the Texas summer heat. (Courtesy of City of Benbrook.)

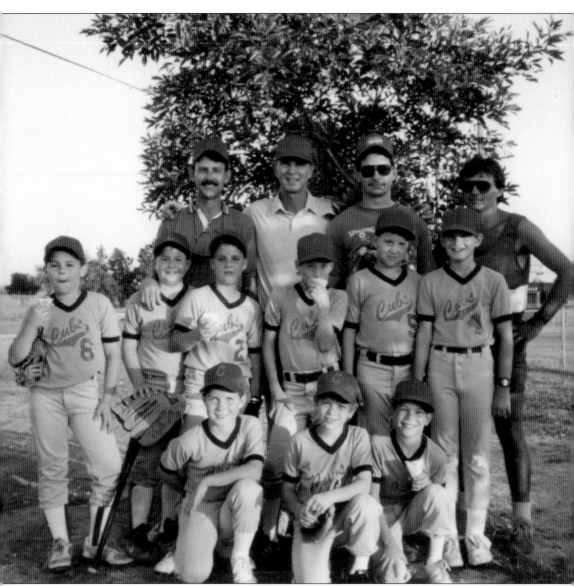

This photograph is taken of the Cubs Little League team in the 1980s. Benbrook offers facilities for many sports opportunities for all ages at Dutch Branch Park. (Courtesy of Chuck Atkinson.)

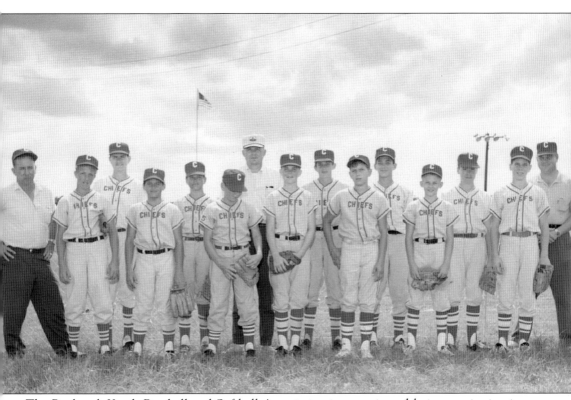

The Benbrook Youth Baseball and Softball Association is an active athletic organization in Benbrook. (Courtesy of City of Benbrook.)

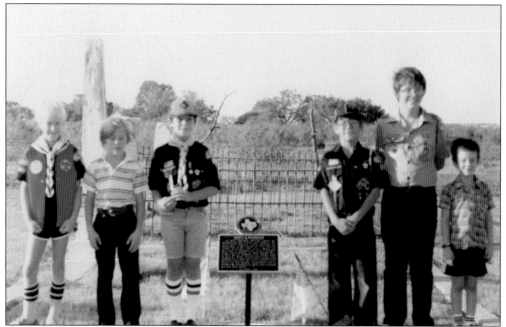

This is a photograph of Boy Scout Den 4, Pack 95, in front of James Benbrook's gravesite. The only Texas Historical Marker in Benbrook, this gravesite was one of many stops for this Boy Scout pack, which spent time learning the history of their community in 1983. (Courtesy of Robert Cook.)

Benbrook Stables, which has been under the direction of several owners, is located on land owned by the US Army Corps of Engineers. This photograph is from a birthday party at the stables in 1988. Today, the stables are still available for trail rides, horse boarding, and events. (Courtesy of Chuck Atkinson.)

For over 20 years, a half marathon and 5K race has started at Dutch Branch Park. Organized by different running groups, the race is considered a practice race for those competing in Fort Worth's Cowtown Marathon. (Courtesy of Eugene.)

Castle Park, the main playground in the city's athletic complex, has become a favorite place for Benbrook children and visitors. The playground was constructed by community volunteers in 1996. (Courtesy of City of Benbrook.)

The Sailing Center on the shores of Benbrook Lake built a land dock so that sailboat shoppers could more easily test the boats. The Sailing Center sold many sailboats in addition to accessories such as booty boxes and new sails. (Courtesy of Chuck Atkinson.)

The Sailing Center was also home to the first Point-of-Sale, or POS, system. Chuck Atkinson, owner of the Sailing Center and former Lockheed Martin engineer, developed the system to assist retail stores in improving inventory. Updated versions of this first POS system are seen in almost all retail stores today. (Courtesy of Chuck Atkinson.)

In October 2007, Benbrook hosted the first Heritage Fest "Cowboy Roundup" event to celebrate the community's milestones of reaching over 150 years as a settlement and the 60th year as an incorporated city. The event highlights the western heritage that has shaped Benbrook since the first settlers came to the area. Festival-goers enjoy dressing the part. (Courtesy of City Benbrook.)

DISCOVER THOUSANDS OF LOCAL HISTORY BOOKS
FEATURING MILLIONS OF VINTAGE IMAGES

Arcadia Publishing, the leading local history publisher in the United States, is committed to making history accessible and meaningful through publishing books that celebrate and preserve the heritage of America's people and places.

Find more books like this at
www.arcadiapublishing.com

Search for your hometown history, your old stomping grounds, and even your favorite sports team.

Consistent with our mission to preserve history on a local level, this book was printed in South Carolina on American-made paper and manufactured entirely in the United States. Products carrying the accredited Forest Stewardship Council (FSC) label are printed on 100 percent FSC-certified paper.

MADE IN THE USA